HAMPSHIRE

Place Names

HAMPSHIRE

Place Names

ANTHONY POULTON-SMITH

AMBERLEY

First published 2009

Amberley Publishing
Cirencester Road, Chalford,
Stroud, Gloucestershire, GL6 8PE

www.amberley-books.com

British Library Cataloguing in Publication Data.
A catalogue record for this book is available from the British Library.

ISBN 978 1 84868 725 7

Typesetting and origination by Amberley Publishing
Printed in Great Britain

Contents

INTRODUCTION

The arrival of the Anglo-Saxons in the fifth century may be regarded as a time of turmoil, yet they brought the culture and language which forms the basis of modern English. Many of today's short and sharp words come directly from this Old English tongue and even if you could hear them spoken today you would be unlikely to recognise a single word.

This is the same with our place names. Ostensibly simple descriptions of those places in the time before the Normans arrived, today we are unable to understand their meaning. In the pages that follow an examination of the origins and meanings of the place names in Hampshire will reveal all. Not only will we see Saxon settlements, but Celtic rivers, Roman roads and even Norman French landlords who have all contributed to the evolution in some degree to the names we are so familiar with.

Not only are the town and village names discussed but also districts, hills, streams, fields, roads, lanes, streets and public houses. Road and street names are normally of more recent derivation, named after those who played a significant role in the development of a town or revealing what existed in the village before the developers moved in. The benefactors who provided housing and employment in the eighteenth and nineteenth centuries are often forgotten, yet their names live on in the name found on the sign at the end of the street and often have a story to tell. Pub names are almost a language of their own. Again they are not named arbitrarily but are based on the history of the place and can open a new window on the past of our towns and villages.

Defining place names of all varieties can give an insight into history which would otherwise be ignored or even lost. In the ensuing pages we shall examine 2,000 plus years of Hampshire history. This book is the result of the the author's interest in place names which has developed over many years and is the latest in a series which continues to intrigue and surprise.

To all who helped in my research, from the librarians who produced the written word to those who pointed a lost traveller in the right direction, a big thank you.

Chapter 1

A

ABBOTS ANN

Recorded as Anne in 901 and Anne Abatis in 1270, this is 'the settlement on the River Ann belonging to the abbot'. Here the Celtic river name, meaning 'the stream among the ash trees', has an addition telling it was a possession of Hyde Abbey at Winchester.

The Eagle public house is a Christian symbol, perhaps a reference to the local Church of St Mary the Virgin where an unusual ceremony has taken place for over 250 years. When a life came to an end and that person had been associated with the village and its church, and that person had also never been married and thus died a bachelor or spinster, garlands of hazelwood (known as virgin wood) or sometimes oak were fashioned into a crown. These were decorated with rosettes of black and white paper showing the same details as would be expected on a headstone, together with the words to the hymns chosen for the funeral service. At the five points of the crown are gloves, symbolising the throwing down of the gauntlet, to dare those who may challenge the purity of the individual and their right to such a service.

A procession of girls carry the crown on wands and, after the funeral, it is hung first over the door of the church for the first week and thereafter alongside others from previous years. Today the most recent dates from the 1970s, while none are found before 1740 as the church was rebuilt in 1716.

Nearby Little Ann has identical beginnings but, as one would expect, was the smaller of the two settlements. Here is the Poplar Farm Inn, which refers to the trees which grew here, often planted as windbreaks.

ABBOTS WORTHY

A place name which undoubtedly comes from Old English *worthig* or 'enclosure' and was the possession of the Bishop of Winchester by 1012. This document details five hides of land being granted by King Canute to Bishop Lufinc which is assumed to

include the area now known by this name. However, in historical documents it is often very difficult to understand which pieces of land are being referred to, for they are almost always spoken of in terms of ownership and not boundaries. This worked well at the time and thus ensued, but a millennium later it is almost impossible to discover the area referred to.

ALDERSHOT

A name recorded in 1171 as Halreshet is from the Old English *alor-sceat*, telling us it was 'the piece of land where alder trees grow'.

Aldershot's history as a military town is well documented and, as may be expected, there are several minor place names which refer to its past. Laffan's Plain is named after Lieutenant-General Sir Robert Laffan (1821-82), who was not only Commander of the Royal Engineers here, but was also responsible for the major landscaping work at the camp in the nineteenth century. Prior to this the place had been known as the Queen's Birthday Parade.

Pubs in Aldershot include the Trafalgar, commemorating the famous battle, and the Garden Gate, a welcoming sign suggesting this was a place for good company and conversation. The Duke of York, Royal Staff and Royal Standard are among the names showing allegiance to the crown and thus the country. Animals in pub signs and names are invariably heraldic, their imagery taken from coats of arms, often those of the landowner or other prominent figures and which give us the Golden Lion, Swan, White Hart and Unicorn. A full coat of arms is displayed outside the Bricklayers Arms. Such trades are common and it is impossible to say if this was due to an earlier career of the owner or landlord, or if it was to tempt those workers as customers.

ALRESFORD

There are actually two places of this name, today known as Old Alresford and New Alresford. The original was recorded as Alresforda in 701 and as Alresforde in Domesday, both showing this is from Old English *alor-ford* or 'the ford at the alder trees'. As the river here is the Alre, it might seem the river has provided the first element and yet the reverse is the case. This rare process is known as back-formation and one which only seems to happen where rivers are concerned.

Alresford is twinned with the French town of Bricquebec in Normandy, itself having a name which refers to the 'bricked in stream' which was clearly used for irrigation and/or to feed a watermill.

The Tichborne Arms public house is named after Sir Roger Tichborne, heir to the baronetcy of Hampshire, who vanished when his ship *La Bella* was wrecked in 1854. Twenty-one years later a man surfaced in the Australian town of Wagga Wagga claiming to be Sir Roger. In the following year of 1866 the man arrived in Paris, France to meet his mother who recognised him instantly as her long-lost son. They travelled together to England, where he met his supposed younger brother, who had taken the title on the death of their father, having presumed his elder brother to be

dead. His brother was not convinced that this was his elder brother Roger, but the latter was intent on pursuing his claim, what was then the longest court case in British criminal history, lasting 188 days.

It was discovered that this was Arthur Orton, a butcher who had been apprenticed to a Captain Brooks aboard the *Ocean*. After sailing to South America he deserted and fled to Melipilla in Chile, returned to London, then Tasmania, eventually arriving in Wagga Wagga in around 1860. It was there, while he was working as a butcher under the name of Thomas Castro, that he saw Lady Tichborne's request for information on her son whom she was sure was still alive.

Orton served ten of the fourteen-year sentence he received for his fraudulent claims. Yet when he emerged he amazingly found continued support for his claim. This enabled him to rekindle his attempts to gain the title and he found enthusiastic counsel in Dr Kenealy, with a seemingly endless supply of donations from a large number of influential and wealthy Victorians.

ALTON

Listed in Domesday as Aultone, this name comes from *aewell-tun* which speaks of 'the farmstead at the head of the river'. The river in question is, of course, the Wey, discussed under its own entry.

Attractive finger post at Alton.

Street name derivations in Alton largely depend upon the era they were cut and therefore named. Butts Lane is an old name, often said to represent the place where obligatory archery practice took place, the 'butts' being a term used to describe the targets. However, the vast majority, as here, refer to the unploughed strip at the edge of the field where the plough team turned.

In recent years, as the demand for more houses and thus street names has increased, and it has become normal for developers to choose themes for their road names. Such names are invariably rural, or chosen from an area which could never be considered controversial. However, they rarely reflect the history of the place, furthermore hardly a town remains without an estate named after trees or birds or flowers, and all mirror each other. Those distinctive names given during that period of rapid growth period during the Victorian era, as entrepreneurs and businessmen paid for the building which was to house their workforce, are no more. While they were chosen from the names of family and friends, they were distinctive as a whole if not individually.

Themes here include horseracing. The main artery is known as The Ridgeway, an ancient path which cuts through the chalk downs of Berkshire and offers views of the Lambourn Valley, a name synonymous with the training of thoroughbreds. Cut off this road are cul-de-sacs named Ascot Close, Salisbury Close, Haydock Close, Epsom Down, Fontwell Drive, Kempton Close and Fontwell Drive. The nobility should be seen as the idea behind Queens Road, Kings Road, Princess Drive, Knights Way, while royal houses

Dickers Lane, Alton.

were the inspiration behind Balmoral Close, the monarch's official residence in Scotland, and Osborne Close, Queen Victoria's home on the Isle of Wight.

There are also a number of bird names, including Plovers Way, Swallow Close, Heron Close, Raven Square, Robin Close, Martins Close, Wren Close, Finches Green, Yellow Hammers, Partridge Green, Linnets Way, Widgeons, Mallards, Grebe Close, Fantails, Eagle Close, Divers Close, Curlews, Buntings, and Accentors Close. However these names allude to the naturalist who is remembered by Gilbert White Way. Born in Selborne on the 18 July 1720, Gilbert White was a noted naturalist and, in particular, ornithologist. His approach to the study of nature was different, for unlike the specimen hunters of his era White chose to observe and listen. Indeed he is thought to be the first person who distinguished the very similar Wood Warbler, Willow Warbler and Chiffchaff by their quite different songs.

Public houses of Alton include Ye Olde Leathern Bottle, a strange name indeed but not because of the bottle but the first element 'Ye Olde'. The bottle and the tankard were made from leather until at least the sixteenth century. Fashioned from this hard-wearing material and sealed with a covering of tar, they had a much greater shelf life than glass. The addition suggests it was an old establishment, yet the very addition of 'Ye Olde' tells us this name is not old at all, for this was never seen in England until it was brought back from North America in the late nineteenth century – mistakenly thought to represent 'the' when it actually was used instead of 'you'.

Gentleman Jim was how the former England and Portsmouth footballer Jimmy Dickinson was known, for during his record of 845 club appearances, including 48 for England, he never received a single booking, never mind being sent off. He is still Portsmouth's record holder for appearances, and his 754 outings for his club are the second highest for a single club. In the modern era of yellow and red cards and transfer fees in the multi-millions, such sporting play and loyalty is a sobering reminder that once the game was played by gentlemen.

The Bell is a common pub name for it is a simple symbol, easily reproduced and instantly recognised. Pubs with this name often include a number, showing an association with the church and the number of bells in the peal at that time and the Eight Bells is one example.

ALVERSTOKE

The earliest records of this name show it as simply Stoce in 948, which by the time of Domesday had become Alwarestoch. This points to an origin of 'the outlying farmstead of a woman called Aelfwaru or possibly Aethelwaru'. It is not often that a female name forms part of a place name, which is unusual for it must have been expected that a woman elder would outlive her spouse and, while the next generation would have inherited, the matriarch would have quite often held the reins until their children were of a capable age.

Alverstoke has a delightful Georgian street named The Cresent. Such a sweeping arc of a street complete with its classic Georgian façade is associated with cities such as London and Bath, but is not out of place here.

To the south on the coast is the seventeenth-century name of Gilkicker Point. This promontory has an almost identical name to a field in Westmorland, although there

is no record of the northern example having a three-sided brick column marking an underwater danger. While there has never been any clue as to the etymology it is, even so, one of the most fascinating of place names, especially considering there was a second marker known as Kickergill.

Early pub names were designed to attract customers, modern names are no different. Very many soon realised that simply conjuring up an image of a rural location or a warm welcome would attract custom, and both criteria are answered in the Village Home public house.

AMPFIELD

While the parish was only officially created in 1894, archaeology has shown that there has been a settlement here on and off for over 7,000 years. We have no idea what these early peoples called the place (aside from 'home'), indeed the earliest surviving records list it as Anfelda, Amfelde and Aumfelde in the thirteenth and fourteenth centuries. These forms are undoubtedly Old English and it is likely that there were earlier Saxon forms which, sadly, are unknown. The first element is the problem for it does not represent anything known which would also fit the name's expected evolution.

If it was Old English *an* we would expect to find some records of Anefeld or Anfelde and, with the suffix *feld*, would describe 'the single open land'. For this to be accepted we have to assume all the records we have are corrupted in exactly the same way, or that the records showing the expected forms are the only ones missing. This is by no means impossible, but it is more likely that the corruptions occurred much earlier than those we have and there is a missing element or syllable. Such is seen quite regularly, a result of names from the Saxon language being used and slurred by the Norman Frenchman, and seems the more likely scenario and possibly represents a personal name. Unless further evidence comes to light we shall never know more than that this was 'the open land' from *feld*.

Pub names here include the White Horse. Here the white horse in question is Mont Blanc II, described as an albino and not the greys we normally see. True albino animals, apart from horses, have pink eyes signifying a lack of pigment. In horses, although the reason is unknown, this condition results in an early death and they have blue eyes.

AMPORT

This name has an unusual etymology and not one we would expect. The earliest listing is from around the end of the thirteenth century as Anna de Port, when the name speaks of the 'place on the River Ann held by the Port family', a family seen elsewhere in the county. The river name is of Celtic origins, describing 'the stream where ash trees grow'.

Locally is the name of Sarson, which has had a rather unusual development. It begins life in 1203 as simply Anne and was said to be held by Richard le Salvage; by 1242 the name was being written as Anna Savage; then in 1269 the name of Sauvageton or 'Savage's tun or farmstead' had appeared for the first time. The modern name is exactly

the same as this late thirteenth-century Sauvageton, simply that in the next seven centuries the name has been slurred and, as a consequence, shortened.

ANDOVER

Records of Andeferas and Andovere, from the tenth and eleventh centuries respectively, tells of 'the place by the ash tree stream'. The Celtic river name of Ann applied to what has become known as the River Anton and also the Pillhill Brook, which shows that while the place name has retained the original stream name the stream has not.

The district and former hamlet of East Anton is recorded as Eston tune and Estentowne in the sixteenth and seventeenth centuries respectively. These forms are rather late and show that by this time the problem with the name had already become fixed, for there is an additional syllable and strictly speaking should be 'the east tun or farmstead', i.e. east of Andover. Similarly the River Anton has taken its name from this place, or possibly from Andover, or even both in which case the three together explain the appearance of the extra syllable for East Anton.

Picket Piece is a modern suburb which can only have been derived from a former field name, although no record of such survives to the present day. This comes from Middle English *pickel* and refers to a 'pointed piece of land', quite likely formed by two converging roads.

The local inns and taverns show allegiance to the monarchy with the George Inn and Queen Charlotte, metaphorically throw their doors wide open with the Welcome Stranger and remind us of the national summer game with the Cricketers Inn. The Foresters Arms is indicative of the Ancient Order of Foresters; the Lamb Inn is associated with the church as is the Cross Keys, symbolising St Peter; and the Magic Roundabout changed its name to reflect the playbarn for young children and its location on a traffic island.

ANNA VALLEY

As seen several times in the previous names this features the Celtic river name meaning 'the stream of the ash trees'. Oddly this is a new place name, derived from a stream name which is at least two thousand years old.

APPLESHAW

This name is recorded as Appelsang in 1200, a name derived from Old English *aeppel-sceaga* and meaning 'the small wood where apple trees grow'.

ASHE

Few surprises here, for this name does come from Old English *aesce* and describes the '(place at) the ash trees'. Records of this name are found as Esse in 1086, Aisse in 1167, and Esshe in 1258.

ASHLEY

A common place name in England, indeed there are two in Hampshire. One near Lymington is listed as Esselie in 1086 and another near Winchester as Asselegh in 1275. Both are identical today and both have their origins in *aesc-leah*, the Old English meaning 'the clearing of the ash tree woodland'.

ASHMANSWORTH

In the first years of the tenth century this place was recorded as Aescmaereswierthe, a name featuring the three Old English elements *aesc-mere-worth* and speaking of 'the enclosure near the pool by the ash trees'.

ASHURST

Standing on the very edge of the New Forest National Park, a name which comes from Old English *aesce-hyrst* and describes 'the ash tree wooded hill'. The only early listing of note comes from 1331 as Asshehurst.

AVINGTON

Found in 961 as Afintune and in 1181 as Avinton, this is an Old English name referring to 'Afa's farmstead'.

Locally we find Hampage Wood which is probably derived from Old English *haenep* and speaks of 'the place where hemp is grown'.

A minor name here is found as Ebincgtune in 900, Ebintune in 1086 and Yabyngton in 1280. This is Yavington which, while it is derived from 'Eabba's farmstead', has clearly been influenced by the parish name.

AVON (RIVER)

This is a river name found several times in England. It is derived from the Celtic meaning simply 'river' and can be seen to be related to the Welsh *affon*.

AVON

A place name coming from the river name above, it is recorded as Avere in 1086. It is most surprising to find it without a second defining element.

AWBRIDGE

From Old English *abbod-hrycg* and listed as Abedric in Domesday, this name means 'the ridge of the abbot'.

Here is the minor name of Stanbridge or 'the stone bridge' which allowed passage over the River Test. For a short period in the fourteenth century there were actually two places of this name, Earls Stanbridge held by Earl Marshal, while Stanbridge Ranville was the manor of the de Raunvile family who hailed from Ranville, of Calvados in Normandy.

CHAPTER 2

B

BARTLEY

Listed as Berchelai in 1107 this comes from the Old English *beorc-leah* or 'the clearing among the birch trees'.

BARTON STACEY

One of the most common place names in England which has a number of origins. However, the most common is Old English *bere-tun* 'the outlying farm where corn is stored' or possibly the simpler 'barley farm'. Invariably places so-named have a second element, as is the case here. With listings of Bertune in 1000, Bertune 1086, and Berton Sacy in 1302, it is clear to see when the de Saci family were in residence while other records show they had been associated with the place since the twelfth century.

Found in the thirteenth century as Auntediche, the ancient earthwork of Andyke takes an Old English *enta-dic* or 'the giant's dyke'. The construction was here hundreds of years before the Saxons arrived and features a typical name from the Saxons, who saw the pre-Christian heathens as Devil-worshippers.

BARTON ON SEA

Another 'Barton' but one with a different origin, as shown by the quite different Domesday record of Bermintune. This is 'the farmstead associated with a man called Beorma', the Saxon personal name followed by Old English *ing-tun*. The addition is for distinction and a clear reference to the nearby ocean.

BASHLEY

Listings of this name are found as early as 1053 as Bageslucesleia and in Domesday as Bailocheslei. Here the Saxon personal name is followed by *leah*, giving us 'Baegloc's woodland clearing'.

BASING

A name meaning 'the settlement of the family or followers of Basa', it is listed as Basegun and Basinges in 871 and 1086 respectively. The place is also referred to as Old Basing which fits with the definition of the following name.

In AD871 the Battle of Basing was fought between the Danes and the West Saxons led by Alfred the Great, in the days before he was king. The region to the north known as Lychpit is the traditional site of a mass burial ground for those who died here, while the reputed battle site is known as Danehill.

There are at least three places in Hampshire named Oliver's Battery, the others being found in Winchester and Old Alresford. Oliver here is Lord Cromwell, the man who became the figurehead of the Parliamentary forces in the English Civil War. There is also an Oliver's Dell here which marks the same events but is not the same place. Cromwell's forces laid siege to Winchester in 1645, and these places in Basing seem to have been named following the name being coined in Winchester. While the name may have been copied for Basing, it was not seen until the early nineteenth century anywhere, for Cromwell's name was vilified for many years and a place name which honoured the man or his family would not be popular.

Pubs here include the Red Lion, still the most common pub name in the land although there are no longer the 600 plus examples that there were at its peak. The name is heraldic and could refer to John of Gaunt, or Scotland, through James I. The Crown is another which shows allegiance to the monarchy. The Hatch takes an old landscape name, referring to a passage leading to a forest.

BASINGSTOKE

Records of this name include Basingstoc in 990 and Basingestoches in 1086, which shows this to be 'the outlying settlement of the family or followers of Basa'. From this it is easy to deduce which is the original settlement, making the much larger place the original overspill. Why Basingstoke was created can only be speculated upon, yet the most obvious reason was that the original was not capable of supporting the population and further farmland was required. It probably began life as a seasonal settlement, only inhabited during the growing or summer months. The earliest records of the two places differ by less than a century and yet, by the time of Domesday, the two were at least equal in size and prosperity.

What are now minor place names of Basingstoke were once independent settlements. Cranbourne is one example, first recorded in 901 as Cramburnan this was known as 'the stream of the cranes' undoubtedly referring to the heron. Eastrop is from Old English *east-thorp* and the suffix itself refers to it being 'the outlying farmstead'. Hackwood

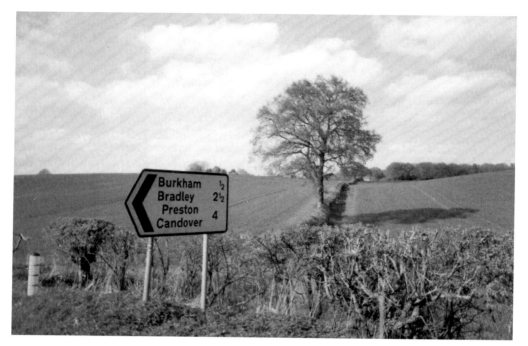

Road sign south of Basingstoke.

Park is recorded as Hagewod in 1228 and Hacwud in 1236, the first suggests this to be 'hawthorn wood' although the latter points to 'gate wood' understood as 'forest gate'. We know the grant for the park was dated 1223 which could be further evidence of the latter definition.

Houndmills is a district name which comes from the mill which also gave its name to those who held the land in later years, the Houndsmill family. Oakridge takes its name from the ridge of oak trees which were here until the estate was built in the 1950s, while South View is the vista afforded by this ridge. South Ham tells us of the 'southern hemmed-in piece of land'. Black Dam controls the flow of a tributary of the River Loddon, creating dark pools of water which are traditionally held to have been where watercress was formerly grown and gathered.

Winklebury is a name recorded as Wiltenischebury in 1290, Wyltenysshbury in 1407, Wynnyshbury in 1443, le Wynlysbery in 1443 and Wincknersbury in 1578. These forms are not consistent and would tend to support the idea that this name is derived from ownership by Walter le Wyltenysshe, Wilton being in neighbouring Wiltshire and the place name suggesting 'the earthwork in a place associated with the family of Wyltensshe'. Hatch Warren did not take the addition referring to 'rabbit warrens' until after the Norman Conquest for rabbits were not here before that time. Prior to that the name simply described the *haecc* or 'gateway' although it is unlcear what the gateway led to.

Street names come from a variety of sources, although the age of the name is a big clue as to its origins. Developers have had a say since the last World War, often producing names which have no recognisable basis such as Churn Close which was

cut in the 1950s. At this same time the name of Valley Road was suggested, yet people power was to emerge victorious when it was officially changed to The Glen, although Glen Avenue or Glen Dale would also have been accepted by the residents. Imp Stone Road existed until 1898 when a white house was built here and the road was instantly changed to White House Road. However, in 1955 the original name returned, an ancient name obviously referring to an unknown item of local folklore.

The strangest of disputes arose in the 1950s when developers received a letter from the rural district council regarding the suggested names of Roman Way, Roman Close and Westlyn Close. These names, all reflecting the history of the area, were described as 'distasteful' by the council because the term close was 'limited to the precincts of a cathedral'. The reply pointed out the term 'close' was more often seen coming from the wholesale enclosures of common land at the end of the eighteenth and beginning of the nineteenth centuries. All three names are still on the map in the twenty-first century.

Basingstoke is twinned with Germany's Euskirchen, a place name speaking of 'Awi's church', and also to Alençon in Normandy, which is derived from the Gaulish personal name Alantio.

Public houses here include the Hammer and Tongs which, while easily seen as a reference to a blacksmith and providing a simple sign, also sends the tongue-in-cheek message of a heated debate. The Popinjay is now used as a term referring to an elaborately dressed person, and is historically spelled without the double 'p'. It is the archaic name of a parrot, itself previously referring to a parrot on pole, the target offered to archers during practice. The Way Inn is clearly an invitation of welcome, which is probably the same message conveyed by the original name of the Bounty Inn. The Hoddington Arms takes the name of an old tithing of Hampshire.

The King of Wessex reminds us that King Alfred ruled here before uniting England, the Golden Lion is an heraldic reference to the Percys, dukes of Northumberland. The Winkle is clearly named for its location on the Winklebury Estate, and is one of the few pub signs with different images on each side. On one side we see the periwinkle, an edible shellfish which was once a common sight at weekends sold by the seafood man, while on the other is a picture of Sir Winston Churchill which we must assume was abbreviated to something like Winkle, although nobody seems to have heard of this.

BAUGHURST

A name recorded in 909 as Beaggan hyrste most likely suggests 'the wooded hill of a man called Beagga'. However, the first element may not be a personal name, in which case this is Old English bagaa-hyrst or 'the wooded hill where badgers abound'. This may not come as a surprise to the locals, for there is a pub here called the Badgers Wood.

Locally we find the name of Heath End, which does indeed refer to a place 'where the heath grows'. Pub names include the Cricketers and the national summer game provides the opportunity to produce a sign with the idyllic imagery of a village cricket match. The Wellington Arms commemorates Arthur Wellesley, 1st Duke of Wellington (1769-1852), the noted soldier and statesman who defeated Napoleon at Waterloo and later served as prime minister.

BEAULIEU

French place names in England are not common, even if the additions often refer to Norman landlords. This name does not appear before 1205, when it is recorded in the Latin as *Bellus Locus Regis*, and around 1300 more like the modern form as Beulu. The two languages here suggests the same meaning, albeit the origin is Old French *beau-lieu* meaning 'the beautiful place (of the king)'.

The River Beaulieu here is named from the place, a process known as back-formation. However, previously it had a quite different name, either 'otter wood' or 'otter stream', depending upon which record is examined.

Harford is a minor place name here describing the '(place at) the grey ford', the colour referring to lichen. There is a small chance of it being 'hare's ford', although this being used as a nickname is more likely than a reference to the native lagomorph.

One local here is the Royal Oak, the second most common pub name in England referring to the Boscobel Oak near Shifnal, Shropshire. This was where Charles II and his aide Colonel Carless hid from the Parliamentarians following the Battle of Worcester in 1651. To mark this famous event, and following the Restoration of the Monarchy, the 29 May was chosen as Royal Oak Day, it being the birthday of the newly crowned king.

BEAUWORTH

A small parish east of Winchester, this place has hardly grown at all in over a thousand years. Listed as Beowyrth in 938, Beowyrthe in 1208 an Beworda in 1280, this describes the place as a 'bee enclosure'. This should be seen as a farmstead where bees were kept and doubtless their golden produce harvested.

Locals enjoy a drink at the Milburys, a pub some 400 years old and alongside a watermill of at least twice that age and a barrow or burial ground even older. Putting together the mill and the barrow gives the name of the pub – The Milburys.

BECKLEY

To the north-east of Christchurch is a name which is a reminder of the small manor here at the time of Domesday when it was seen as Bichelei. With only this and Beckele in a document of 1294 as evidence, it is difficult to see if this is 'Beocca's woodland clearing' or 'Bicca's woodland clearing'.

BEDHAMPTON

A name which is recorded only in Domesday, as Betametone, is difficult to define. As explained in the introduction, the contrasting languages of the Normans and Saxons make proper names unreliable. However, we have no alternative early forms and are forced to consider this as a fairly accurate record, thus this probably comes from Old English *bete-haeme-tun* or 'the farmstead of the people who grow beet'. Note that in

order for this name to have stuck that particular crop must have been grown for some time, or at least have been an important source of food.

BEECH

A name from Middle English and not its earlier form of Old English, the language which links the Saxon tongue to our modern English. Listed as la Beche in 1239 and as (atte) Beyche in 1334, this second offering shows the understanding of it being the '(place) at the beech tree'.

BENTLEY

A place name found throughout the land and always from Old English *beonet-leah* or 'the woodland clearing where bent grass grows'. Although grasses are a highly adaptable plant group, none have yet evolved to grow horizontally and thus this cannot be the suggestion here. Any name describing a region has to refer to something which has existed for some time or is a reasonably permanent sight. Thus 'the woodland clearing with the bent grass' enables us to see that the grass was allowed to grow without being grazed until a point is reached where the grass collapsed under its own weight, no longer able to support itself against the elements. Furthermore, we can deduce from this that the people living here dissuaded wild animals from coming here by their presence, while they had no livestock of their own. This would mean they were supported by another community and were not farmers. It would be expected that any religious or military presence would be noted and, in the absence of such, we could conclude this to have been the abode of a group of outlaws. The name is recorded as Beonetleh in 965 and Benedlei in 1086.

The Bull is one of the most common images on English pub signs, which is due to a number of reasons. Aside from the obvious, that of a large animal and probably one which was greatly admired locally, it is also featured as an instantly recognisable symbol in a coat of arms carrying a number of messages. However, the least obvious is one of the most common, a religious message and a reference to the Pope, for the seal used on any edict issued by the papacy is known as a Papal Bull. The Star is a pub which has no connections with the cosmos, but is named after a car model although how this is associated with the pub is unknown.

BENTWORTH

A name recorded as Binteworda in 1130 which comes from a personal name with the addition of Old English *worth* and speaking of 'Binta's enclosure'.

Bentworth today has two public houses. However, it did have three for the Moon Inn was demolished around 1921. Whichever was the original of the Sun Inn and the Star Inn, these names have a theme and the reason behind their naming was forgotten long ago.

BERE FOREST

Today there is little remaining of a forest which once covered a large area north of Fareham. Indeed it could be argued to be a minor place name. Yet historically this was actually counted as two forests, East Bere and West Bere, and was an important area. The name comes from Old English *baer* meaning 'swine pasture', a reference to the rights of pannage today only practiced in the New Forest areas where it is known as Common of Mast. This alternative name is a reference to why the pigs are released here, to dine on acorns (fruit of the oak tree) and beechmast (fruit of the beech tree). Pigs can dine on this rich source of food without coming to harm, while ponies, deer and cattle would soon be poisoned.

BICKTON

Listed as Bichetone in Domesday, this name comes from the Old English for 'Bica's farmstead'.

BIGHTON

Records of this name include Bicincgtun in 959 and Bighetone in 1086, or 'the farmstead of a man called Bica'. Nearby is the name of Gundleton which, owing to a lack of forms before the fourteenth-century recordings of Gunnildcroft and Gonyldegate, is difficult to define with any certainly but would be something akin to 'Gunild's farmstead'.

The local is the Three Horseshoes, a common name derived from its sign. During the days when the horse was the only form of land transport, the needs of the horse and the rider became entwined and thus the blacksmith would naturally make his place of work alongside the tavern. In order to advertise the blacksmith old horsehoes would be nailed to a board at the side of the road, and three was the most common for a horse needs four shoes and the last could be obtained here.

BINSTED

From the Old English *bean-stede* and recorded as Benestede in Domesday, this is undoubtedly 'the farmstead where beans are grown'.

Local names include that of South Hay, a name of Old English origin and describing 'the southern enclosure'. The parish church is dedicated to the Holy Cross and is the last resting place of Bernard Law Montgomery, 1st Viscount Montgomery of Alamein who spent his retirement years here after a successful military career including leading the Allied forces to victory in the North Africa Campaign of the Second World War.

BISHOPSTOKE

Records of this name show the evolution of the place from Stoches in 1086 and Stoke Episcopi in 1270 to come from Old English *stoc*. This name refers to 'the outlying

The remains of the Bishop's Palace, which gave part of the name to Bishop's Waltham.

farmstead belonging to the bishop', and thus where an earlier outlying settlement belonging to a neighbouring place was later held by the Bishop of Winchester.

Here a hunting park was enclosed in a region which had previously been a dependent or outlying settlement. Both aspects are reflected in the name of Stoke Park. During its history Bishopstoke has produced three important figures who have had very different influences over the years: John Bale was a sixteenth-century churchman and Bishop of Ossory who is best remembered for his ground-breaking historical verse drama on King John; Thomas Garnier was Dean of Winchester in the nineteenth century and was instrumental in producing the first effective sewage system in Winchester, he was also a noted botanist who helped found Hampshire Horticultural Society in 1818; lastly Samuel Sewall, who was born here but emigrated to Massachusetts where he was a congressman and, more famously, a judge in the Salem Witch Trials – a role which he later very much regretted and publicly apologised for.

BISHOPS SUTTON

Listed in 982 as Sudtunam and as Sudetone in 1086, this is clearly from Old English for the 'south tun or farmstead'. The addition is from it being held by the Bishop of Winchester at the time of the Domesday survey.

BISHOPS WALTHAM

A common place name, hence the addition which denotes it was held by the Bishop of Winchester. Listed as simply Waltham in 904 this comes from Old English *weald-ham* and describes 'the homestead in a forest'.

Denewulf Close is named after the Bishop of Winchester, who died in AD909; Beaufort Drive recalls another cardinal, Henry Beaufort, who died in 1447; Edington Close remembers William Edington, Bishop of Winchester until his death in 1366; Langton Road is named after Thomas Langton, Bishop of Winchester who was elected Archbishop of Canterbury in 1501 but died before he could take office; and Morley Drive was named after Bishop George Morley who died in 1684.

Pub names locally include the Hampshire Bowman, a reminder that the beginnings of the Hampshire Regiment lie in the bowmen who served their country at Agincourt. The Bunch of Grapes is a fairly easy sign to reproduce, making it cheaper, and it is easily recognisable as being associated with drink, making it an effective advertising hoarding even in times when the majority of the population were illiterate.

BISTERNE

Recorded in Domesday as Betestre and as Budestorn in 1187, this undoubtedly comes from the Old English for 'the thorn tree of a man called Bytti'.

BITTERNE

Despite the similarity with the previous name, the two have quite different origins. Here the name is found in 1090 as Byterne, which comes from Old English *byht-aern* meaning 'the house near a bend'. The bend is clearly that formed by the meandering River Itchen.

One local pub has an intriguing history. It was built around 1860 when it was named the Commercial Inn, taking the name of Commercial Street where it is located. Around 1980 the pub closed and was eventually bought by Charlie Brown who decided to have his name outside and called the place Charlie Brown's. He later bought other pubs and, rather than having other pubs named after him, decided to name them from a theme. As he was a builder this was the chosen theme, he named one the Builder and for this place chose the name the Humble Plumber. Examine the sign and the plumber can be seen working, while underneath the signwriter ran out of room and the Humble Plumber became The Humble Plumb, the name which is still on the sign today.

BLACKFIELD

A comparatively recent name, as far as place names go, and which which is self-explanatory.

BLACKMOOR

Listed in 1168 as Blachemere, this is from the Old English *blaec-mere* meaning 'the dark-coloured pool'.

BLASHFORD

A small hamlet which has a long history and was certainly around before the earliest surviving records of Blachford in 1170, Blecheford in 1248 and Blaschforde in 1429. Often in defining place names we find elements which, while clearly a personal name, are unknown other than in records of place names and such is the case with Blashford. Such personal names are often difficult to give with any degree of accuracy, while the thinking behind any nickname is invariably relevant only to the individual and something we can only speculate upon. It is thought this represents 'Blaecca's ford' with the name derived from Old English *blaec* or 'black' – this could refer to a man of swarthy complexion or perhaps of an almost permanently unclean appearance.

BLENDWORTH

A name derived from the Old English suffix *worth*, this speaks of 'Blaedna's enclosure' and is listed as Blednewrthie in 1170.

BOARHUNT

An unusual place name recorded in the tenth century as Byrhfunt and as Borehunte in Domesday, the name has nothing to do with either boars or hunting. Derived from the Old English elements *burh-funta* this means 'the spring of the fortified manor'.

BOLDRE

Sometimes a place name has defied all attempts to find its origins and Boldre is one such example. It is listed as Bolre in 1152 and as Bovre in Domesday which, despite its appearance, shows the name is not Old French or it would have been listed closer to the modern form. It seems likely this is the original name for the Lymington River, but without early records to help the origins will remain unclear.

 A small hamlet here is South Baddesley, itself from 'Baeddi's woodland clearing' with the addition to distinguish it from the better known North Baddesley twenty miles north of here. There is no suggestion that the two places were named from the same person, as the distance between them is simply too great. Pilley is an Old English name referring to 'the wood where shafts or piles were obtained', clearly managed woodland. Walhampton is an Old English name featuring the three elements *weall-ham-tun* and meaning this was 'the ridge or bank of the homestead farm'. Warborne is shown as Wereburne in 1212, a name which speaks of it being 'the stream with weirs or fish traps'. When it came to feeding the settlement the rod and line method of fishing was inefficient, for much more fish was eaten in Saxon times than it is today. Thus poles were driven into the bed of the stream to funnel the fish into gaps where strategically placed wicker baskets were anchored where the fish became trapped but kept alive until the traps were checked some time later.

BORDON

The only early form of note comes from around 1230 as Burdunesdene. With no other records available it would seem this is the '(place at) Burdun's hill'. In fact, we know there was a de Burdon family living here around this time and, if we can assume the normal evolution of a place name, took their name from a much older name for the place. However, while the suffix here is undoubtedly Old English *dun* or 'hill', there are at least five possibilites for the first element, which could have almost twice as many meanings. Without further evidence we shall have to content ourselves with the family name as the sole explanation.

BOSSINGTON

Listings of this place include Bosintone in 1086, Bosinton in 1167 and Bossinton in 1200. Undoubtedly this is from a personal name and Old English *tun* and speaks of 'Bosa's farmstead'. The same Saxon personal name is found nearby, over the border in Bosham, Sussex.

Locally we find Pittleworth, recorded as Puteleorde in 1086, Puteleworth in 1280 and Piteleworth in 1341, which seems to point to 'the hawk's enclosure'. Yet this would be an unusual combination and the first element is possibly a nickname or personal name.

BOTLEY

The most pleasing place names to the author are those which produce a snapshot, an image of life in the Saxon era. Botley is one such example, coming from Old English *bot-leah* and recorded as Botelie in Domesday, it describes 'the woodland clearing where timber is obtained'. This cannot be suggesting the clearing was where trees had been cut down for timber, the element *leah* is used almost exclusively for a natural clearing and felling trees would not be at all unique to the area. Hence this is understood to be where timber was stored, having been cut and maybe even seasoned, and to be sold or traded for other goods.

Local pub names include the Bugle Inn Hotel. The bugle is otherwise referred to as a coach horn and was used by the guard of a horse-drawn coach for the same reasons as a car horn would be used today. The name of the pub is a welcome alternative to those normally found for coaching inns. The Dolphin is rarely a reference to the aquatic mammal once held to come to the rescue of mariners by entwining itself around the anchor cable to help secure a vessel in a storm. More often the name is heraldic, and fishmongers feature the creature in their coat of arms. Even more commonly it is simply a family name.

BRADLEY

Domesday lists this as Bradelie, a common place name found throughout England and from Old English *brad-leah* 'the broad woodland clearing'.

BRAISHFIELD

Listings of this place name are limited to Braisefelde in 1235. While the suffix is clearly from the Old English *feld* 'open land', the first part of the name is less obvious but thought to represent *braesc* referring to 'small branches, or brushwood'.

The Wheatsheaf has been a common pub name since the seventeenth century. Heraldic in origin, the device is found on the arms of both the Worshipful Company of Bakers and those of the Brewers' Company.

BRAMDEAN

Recorded as Bromdene in 824 and Brondene in 1086, this name comes from Old English *brom-denu* or 'the valley where broom trees grow'.

The Fox Inn is a common name, as widespread in England as the instantly recognisable creature itself. Rarely is the original reference to the hunt, more often the animal is depicted displaying the many traits associated with it being crafty or sly, dressed as a dandy and often enjoying a glass of his favourite tipple.

BRAMLEY

The only record of note to survive is that from Domesday as Brumelai. This name comes from the Old English *brom-leah* which tells us it was 'the woodland clearing where broom trees are seen'.

Moat Close is an early developer's street name surviving from the 1950s.

BRAMSHAW

From Old English *braemel-sceaga*, this place name has its origins in 'the wood or copse where brambles grow' and is listed as Bramessage in Domesday.

Here we find a stream with the unusual name of King's Garn Gutter which, in 1670, is found as King's Gairn stream. This royal manor takes its name from when the bee-keepers in the forest would move their hives on to heathland when the heather was in flower. To prevent the New Forest ponies from disturbing the bees, the hives were arranged in banks forming enclosures which created a large central area exclusively for the bees. These were known as 'bee gardens' and the modern name is a contraction of the 'garden' and thus this was 'the king's bee garden channel'.

BRAMSHILL

Literally meaning 'the hill of the broom', the name is derived from the Old English *brom-hyll* and suggests it is where broom trees grow. Domesday is the only record of note, where it appears as Bromeselle.

The lych gate at St Mary the Virgin, Bramshott.

BRAMSHOTT

Listed as Brenbreste in the eleventh century, this name comes from Old English *braemel-sceat* or 'the projecting piece of land where brambles grow'.

Minor names here include Ludshott, a name found recorded in Domesday as Lidessete when it was a separate manor. Here a stream name from *hlyde* 'the loud one' precedes another Old English term *sceat*, 'the nook or angle of land'. Today there is no topographical feature to fit a nook of land, hence this was probably created by a different water course or very dense vegetation. Passfield is a Middle English name meaning 'the field of parsley' and not recorded until 1639 as Parsfeild. The Domesday manor of Coltelei is today known as Chiltlee, a name meaning this was originally referred to as 'Cilta's woodland clearing'.

Bramshott can lay claim to being the most haunted place in the county, if the reports and sightings are expressed as a ratio against the population. No less than sixteen different figures are recorded including an ancient cat and also a pig. However, the most famous visitor from beyond the grave is a gentleman who came to Bramshott for the last years of his life, the actor whose name is synonymous with horror films and who still walks these lanes, Boris Karloff.

B

BRANSBURY

A name found in 1046 as Brandesburi, while Domesday lists Brandesberee in 1086. This name refers to 'Brand's burh' from Old English and *here* meaning 'stronghold'. Here the personal name is Scandinavian, although this does not necessarily mean the individual was of Scandinavian birth.

BREAMORE

Found in 1086 as Brumore, this name features the Old English elements *brom-mor* and speaks of 'the moor or marsh where broom trees grow'. The local pronunciation is 'Bremmer'.

Locally is the minor name of Charford, today seen in the road names of South Charford Drove and North Charford Crossing, and the basic name has a potentially intriguing history. A record of 519 speaks of the victorious Cedric and Cynric, finally defeating the Welsh in the Saxon kingdom of Wessex, of which Hampshire was a part. Around 500 years later we find the same battle referred to as being *in fluvio Avene* or 'on the river Avon'. It cannot be said to be direct evidence but there must be a good chance that this is 'Cerdic's ford', and thus one of the few personal name elements in a place name where something of that individual is known.

Grims Dykes are ancient earthworks said to have been built by the giant known as Grim. This is understood to be an alternative name for Woden. Outwick is 'the outlying specialised farm' as the modern form suggests, with the Old English element *wic* or 'specialised farm' more often than not referring to a dairy farm.

The local inn is the Bat and Ball, celebrating the birth of cricket in Hampshire.

BROCKENHURST

With just two records of note, as Broceste in 1086 and Brocheherst in 1158, the first element here is uncertain and there are two possible meanings. The more likely is a personal name followed by *hyrst* and thus 'Broca's wooded hill'. However, the first element may be *brocen* which can still be seen as 'broken' and understood to be 'undulating wooded hill'.

Locally we find Connigers Copse, a name which speaks of the time at the end of the twelfth century when rabbits were introduced to this country by the Normans. This reference to 'the rabbit warren coppice' reminds us that the animals which many see as pests were introduced for food and, within a few short years, they had escaped into the wild and had quite literally bred like rabbits resulting in the population we see today. Rhinefield is a regional name which began life as a field name, for the early forms from the fourteenth century of Ryefeld and Riefelde point to 'the rye open land'.

Seen as Reidon in 1284, Reydone in 1333, and Roydon in 1573, the name of Roydon is derived from *raege-dun* or 'the hill of the female roe deer'. Setley is first seen as Setle in 1331 and, although enclosing any plantation against wild animals was considered illegal until the law was changed in 1483, this can only refer to 'the set out or planted

The river at Brockenhurst.

woodland'. The name of Hincheslea tells us it was where 'hind calves frequented a woodland clearing' and possibly shows these immature females were being kept for meat and their hides.

Brockenhurst has some of the most informative pub names in the county, perhaps even the country. While the Filly is clearly a reference to the female New Forest ponies under the age of four, it is a very unusual name. The Morant Arms remembers Edward Morant who, in 1770, came to Brockenhurst House which he purchased for over £6,000. However, this was not the end of his spending for he completely rebuilt the home, a resplendent Georgian mansion with beautifully laid-out grounds and over 3,000 acres of land in total. His fortune came from the family estates in Jamaica. He is also remembered as being an amateur cricketer of considerable ability who organised many matches here at the end of the eighteenth century. The Turfcutters Arms is not what it may seem, for the 'turf' is a reference to a slab of peat which was dug hereabouts as a fuel.

However, there can be none more unique a pub name than the Snakecatcher. Brusher Mills was born Henry (known as Harry) Mills in March 1840, one of eight children. He lived in the hut of a former charcoal burner, a simple affair with a bed of dry bracken, a chair, firewood kept in an old biscuit tin, a single spoon he had fashioned himself, and his tin of tobacco. He was not ashamed of his simple home and would often invite visitors inside for a cup of tea (plenty of sugar but no milk). A

The former Railway Tavern at Brockenhurst.

cleft palate made his speech difficult to comprehend, although tradtion has it that this was the result of a gypsy curse.

Harry 'Brusher' Mills was the snakecatcher, he caught adders to earn a living. Leaving his home in the early morning he would walk miles around the New Forest every day, a tin with holes in one hand, a sack over his shoulder, and a second sack carrying the tools of his trade – scissors, knives, tweezers and a forked stick. The adders would be caught, killed and stripped of the fat which would be melted down to produce an embrocation used for a multitude of ailments and troubles, including sprains, bruises, rheumatism, and, of course, adder bites. Such cures were trusted, which was not surprising, as other commonly held beliefs were that touching the body of a hanged man was the only way to rid a person of St Vitus Dance, while fits would be banished by eating the livers of no less than forty green frogs.

The majority of his catches were grass snakes, which he could sell the skins of as souvenirs. During his lifetime it is estimated Brusher, a name thought to be derived from the way he brushed the bracken aside to find his quarry, caught almost 30,000 snakes of which only one in every eight was an adder.

Harry died at the age of sixty-five, the result of heart condition. His last meal of meat, bread and pickles was unfinished, the drink still alongside on the table, and he was found in an outhouse of his favourite pub, then called the Railway Tavern but today renamed the Snakecatcher in his honour.

BROUGHTON

Recorded as Brestone and Burchton in 1086 and 1173 respectively, this comes from the Old English *beorg-tun* and means 'the farmstead by the hill'.

Minor names here include Roake, which is seen from the fourteenth century and refers to the region being 'at the oak tree'. Local pubs include the Greyhound, usually depicting the dog but the oldest would mark the route and stopping place of a famous mail coach, and the Tally Ho public house which takes its name from the cry sent up by foxhunters when their quarry was espied.

BROWN CANDOVER

Recorded as Cendefer in 880, as Candovre in 1086 and Brunkardoure in 1296, this name comes from the stream. Here a Celtic river name describes the 'pleasant waters' and is distinguished from nearby Preston Candover by the addition of the name of the Brun family, who held this manor by the thirteenth century.

Gravel Close is an early developer's name from the 1950s.

BUCKHOLT

Listed in Domesday as Bocolt and as Bocholte in 1231, this name comes from Old English speaking of 'the beech wood'. Furthermore we can also say that the use of *holt* points to this being a managed woodland, most often of a single species of tree grown for a specific purpose or market.

BUCKLERS HARD

A very recent name in comparison to most, it first appears in 1789 exactly as it does in the twenty-first century. It is named from the Buckler family, who were certainly here by 1664, together with the dialect term *hard* meaning 'a firm landing place'.

BULLINGTON

A small hamlet which has existed for over a thousand years, found as Bulandun in 1002, Bulindon in 1218, Bulendun in 1236, and Bulyngton in 1280. This name refers to either 'the dwelling on the hill of a man called Bula' or 'the home on the hill of a bull'. If the latter is the case it must have been a very famous and impressive animal indeed.

Tidbury Ring is an earthwork here and takes its name from 'Tuda's stronghold with a ring ditch'.

BURGATE

Found as the modern form as early as 1250, this place is also seen as Borgate in Domesday. Here the origin is Old English *burh-geat* and describing 'the route to the fortified place'.

BURGHCLERE

Found in 1171 as Burclere it was originally called Highclere to which was added Old English *burh* meaning 'fortification'. It is easy to see the ramparts of this hillfort clearly silhouetted against the sky when driving north along the A38.

BURITON

Found in 1178 as Burgelea, this name is derived from the Old English *burh-leah* and meaning 'the woodland glade by the fortified place'.

The most obvious and prominent feature here is Butser Hill, at 270 metres one of the highest points in Hampshire. This name comes from Old English and describes the '(place at) Briht's slope'. Nurstead was a place name in 1204 and is now applied to a lane and a farm, both referring to the 'place of the nut trees'. Records of Sunwood appear with the Old English suffix *worth* until 1759 when it is first seen with 'wood', thus the name originally referred to 'Sunna's enclosure'.

Bells are associated with the church and, as a pub name, makes a simple and easily recognisable symbol. The Five Bells public house also shows the number of bells in the peal of the parish church. Master Robert Inn refers to a horse that won the Aintree Grand National in 1824.

BURLEY

From Old English *burh-leah* and speaking of 'the fortified place in the woodland clearing', this small region of the New Forest was probably founded around the same time as the royal hunting forest. It is recorded as Burgelea in 1178, Borlegh in 1212, and as Borghley in 1301.

Locally is the name of Holmsley Walk, a forest path which comes from Old English *holegn-leah* or 'the woodland clearing where holly is seen'. Picket Post is a name found attached to several different locations over the years, the basis would have been a 'pointed post' and a marker, perhaps a meeting place or a boundary point.

BURSLEDON

A place name meaning 'the hill associated with a man called Beorhtsige' is recorded as Brixendona at the end of the twelfth century and is derived from the Old English *ing-dun* following a Saxon personal name.

The Linden Tree is a pub which takes its name from a tree which stood here, a focal point and a pointer to the location of the pub. The Crows Nest may show the most precarious perch high above the rigging of the sailing ships, but the real origin is the original crow's nest high among the branches of trees the length and breadth of England.

BURTON

A very common English place name, the only surprise being the lack of any addition for distinction as is normally the case. Listed as Buretone around 1100, as Buritoton in 1236 and as Burton in 1248, this name comes from Old English *burh-tun* and describes the 'fortified farmstead'.

CHAPTER 3

C

CADNAM

One of the most unusual place names in the county describes 'the homestead of a man called Cada'. Listed as Cadenham in 1272, it is derived from a Saxon personal name followed by the Old English element *ham*.

Two pubs here recall more of the history of the place. The name of the White Hart is a heraldic reference to Richard II who had inherited it as a device from his mother Joan, the 'Fair Maid of Kent'. The Sir John Barleycorn reminds us of an English folksong telling the story of barley, an important cereal crop but one which seems to do more harm than good. Each of the verses reminds us how the stresses and strains on the body involved in producing the crop were compounded by the use of the grain in malting and brewing and, finally, by drinking the resulting whisky and beer. John Barleycorn is the personification of barley and suggests that while it may seem that man has control over the grain, the grain leads to the ultimate death of the man.

CALMORE

Three early forms of this name all date from the thirteenth century, as Cauwelmor, Caulemore and Kaulemor. Undoubtedly these are from Old English *cawel-mor* which is literally 'the cabbage marshland' and would refer to sea kale, the common name of *Crambe maritima*. This had long been known locally as a food source (hence the name) when William Curtis decided to capitalise on its value and shipped it to London and Brighton where it was enjoyed by the Prince Regent (later George IV) and other members of high society. A short-lived delicacy for the gourmet palates of the rich, as it does not travel well and really needs to be cooked and eaten within a few hours of being cut in order to savour it at its best. Even today it would be difficult to serve sea kale growing wild on the brackish tidal waters of the Test in the finest restaurants of London within hours. Because of this its popularity soon waned.

However, it is a fine addition to any meal and, grown in suitably prepared beds in a private garden, can be blanched like leeks in the ground and cooked in much the same way as asparagus.

CALSHOT

Listed as Celcesoran in 980 and Celceshor in 1011, this comes from the Old English *ord* meaning 'point or spit of land' preceded by an uncertain first element. It has been suggested this is Old English *caelic*, which means 'cup or chalice' but if this is so it is not clear in what topographical sense this is used.

CATHERINGTON

Listed as Cateringatune around 1015, this name most likely comes from 'the people in the farmstead by the hill called Cadeir', with the hill name a Celtic word meaning 'chair'. Alternatively it could be a Saxon personal name and describe 'the farmstead of the family or followers of Cattor'.

Minor names here include Hinton Daubeney. The first element is from Old English *hean-tune* or 'the high farmstead' with the addition of the name of the d'Aubeney family who are not otherwise recorded here and came from the village of Aubigny in the Calvados region of Normandy.

The local here is the Farmer Inn, a reminder of its rural location and the identity of the original customers.

CHALTON

Records exist of Cealctun and Ceptune, from 1015 and 1086 respectively. These are from Old English *celac-tun* and tell us this was 'the farmstead on the chalk lands'.

The local here is the Red Lion, the most common pub name in the land and referring to either John of Gaunt or to Scotland. It dates from the twelfth century and is claimed to be the oldest pub in the county.

CHANDLERS FORD

A quite recent name, not seen before 1759. However, those who gave the ford its name, the Chaundler family, were here from at least the fourteenth century. Locally is the name of Boyatt Wood, an old manor name from Old English *bufan-geate* meaning 'the place above the route', most likely where the Itchen valley narrows and would have made an obvious crossing point.

Minor names here include Fryern Hill, a suburb which takes its name from the Middle English 'friar's hill'. Hiltingbury is found in thirteenth century documents as Hiltyngebury and as Heltyngbur. This comes from the Old English description as 'the stronghold of a tribe called the Hyltingas'.

Pubs here include the King Rufus, the name given to William II owing to his red hair and complexion; Monksbrook, taken from the landscape and suggesting the land here was once held by the Church; the Halfway Inn could have been halfway between two points although it is difficult to understand which two points owing to inaccuracies in measurement and modern developments; and Cleveland Bay, an impressive breed of working horse from previous centuries.

CHARLTON

Recorded in 1192 as Cherleton, this is a common place name derived from Old English *ceorl-tun* or 'the farmstead of the freemen or peasants'.

CHAWTON

A place name recorded as Celtone in Domesday, which is the only record of the place we have and does not help to discern between the two potential origins of this name. Either this is identical to Chalton (q.v.) and is 'the farmstead on the chalk lands' or this is from Old English *cealf-tun* and means 'the farmstead where calves are reared'.

The Greyfriar public house reminds us of the friars that once lived here, and named for the colour of their habits.

CHERITON

Listed as Cherinton in 1167, this comes from the Old English *circie-tun* or 'the settlement with the church'.

The Flower Pots Inn, one of the very few remaining pubs to still be brewing its own beer, has a name which is of religious origin. It is not the pots themselves which were important but the flowers, always lilies and referring to the Virgin Mary.

CHIDDEN

A Saxon personal name followed by Old English *denu* gives a meaning of '(place in) the valley of a man named Citta'. The earliest record of this name comes from 956 as Cittandene.

CHILBOLTON

The 'farmstead associated with a man called Ceolbald' is listed as Ceolboldingtun in 909. For once this early tenth-century record is perfectly recorded, the Saxon personal name followed by the Old English *ing-tun*.

CHILCOMB

Recorded as Ciltancumb in 909 and Chiltecumbe in 1171, this name comes from Old English *cumb* or 'valley' following a Celtic word *cilta* or 'slope', which was clearly interpreted by the Saxons as being the name of the hill.

CHILWORTH

Recorded in Domesday as Celeorde, this place name is derived from 'the enclosure of a man called Ceola'. The Chilworth Arms is the present name of the pub which was once known as the Clump. However, the Clump was not considered an attractive name, although the name simply describes the landscape in which it was built.

CHINEHAM

The present form is exactly as recorded in Domesday, the only early record we have. This seems to be from Old English *cinu-ham* or 'the homestead in a deep valley'.

CHURCH CROOKHAM

Listed as Crocham in 1248, this place name is derived from the Old English for 'the homestead where the river bends'. The addition, required for the nearby place of Crookham in neighbouring Berkshire, indeed refers to it having a church.

The local is the Wyvern, a mythical monster which was a winged dragon with the feet of an eagle and the tail of a serpent. The creature is a device found in various coats of arms, including that of the Duke of Rutland.

CHUTE FOREST

All the early records of this name come from the thirteenth century, as foresta de Cet, Schete and Chut. This simply describes this region as 'woodland' and is from an early Welsh *ced*, or possibly a similar root coming from the earlier tongue.

CLANFIELD

From the Old English *claene-feld*, recorded as Clanefeld in 1207, this tells us it was the 'clean open land'. This tells us it was farmland free from weeds and not otherwise overgrown, ideal farmland it would seem.

The local is the Rising Sun, which is a welcoming sign whose origins are heraldic, featuring in the arms of many landed families throughout history and the families of Edward III and Richard II.

CLANVILLE

Despite the records from Domesday as Clavesfelle and in 1259 as Clanefeud, this is identical with the previous name and 'the clean open land'.

CLIDDESDEN

Records of this name include Domesday's Cleresden and as Cledesdene in 1194. This is probably from Old English *clyde-denu*, meaning 'the valley of the rocky hill'.

The local is the Jolly Farmer, a reference to the rural location and in addition used to suggest the named patron was a warm and friendly fellow.

COLBURY

To the west of Southampton is the place recorded as Colebir in 1250 and Colebur in 1280. The suffix here would seem to be Old English *burh*. However, there are no known earthworks here and is thus probably used to describe 'Cola's manor'.

COLDEN COMMON

Found as Colvedene in 1208 this has been difficult to define, principally through a lack of other early forms for comparison. However, it is thought to be Old English *colfa-denu* and meaning 'the cleft of, or in the valley'.

Locally is the name of Hensting, recorded as Hefesylting in 970, as Hevenstigge in 1208, as Hevelesting in 1231 and as Havelstyng in 1350. This seems to be derived from Old English *haefeleast* meaning 'want, poverty' and describing the thin but fertile soils here. It is known that the soil is naturally lacking in potassium and magnesium, which would have been clear from the quality of the barley. Further evidence of the poor quality agricultural land is supplied by the post-Conquest use of this land for rabbit warrens, something which would not have been encouraged for land which had proven fruitful.

COLEMORE

Listed in Domesday as Colemere and as Culemere in 1196, this name comes from Old English *cola-mere* and describes the '(place at) cool pond'. There does not seem to be any evidence of a pond here today, yet there is no reason to believe this was not the case in the past.

COMPTON

This is a common English place name, nearly always found with a second defining element. From Old English *cumb-tun* or 'the farmstead in a valley' the name is recorded as Cuntone in 1086.

COOMBE

Unusual to find an Old English place name from a single element. Here *cumb*, a common element in the in the south-west of the country, speaks of the '(place at) the valley'. Domesday records the place as Cumbe in 1086.

COPYTHORNE

A name from Middle English, recorded as Coppethorne and Copped Thorne, the name refers to 'the pollarded hawthorn'. To find one such hawthorn would not be thought sufficient to give the name, thus it is likely there were a number of hawthorn trees although why they were cut in this manner is uncertain.

The local pub is the Empress of Blandings, a fictional pig featured in stories by P.G. Wodehouse. Owned by Lord Emsworth in the Blandings Castle series of novels, this black Berkshire sow was famed for her great size and won a multitude of prizes at shows. In many of the novels the pig is central to the plot, yet plays no part in the story (it is, after all, merely a pig) and is usually kidnapped by rivals for a multitude of reasons.

CORHAMPTON

With the thirteenth-century record of Cornhamton as the only piece of evidence we have, this name is still clearly from Old English *corn-ham-tun* or 'the home farm where grain is produced'.

COSHAM

Domesday records this as both Coseham and Cosseham, which points to the known personal name and giving 'Cossa's homestead'.

Minor names here include Paulsgrove, a name which is recorded as Pallesgraffeld around 1300, Palesgrave in 1319 and Pallesgrove in 1321. These early records probably show the personal name to be Paelli, while the suffix could be Old English *graf* 'grove', *graefe* 'quarry' or *grof* 'groove'. There is no connection with the modern quarry, for the place name existed centuries before this.

The Churchillian is named after the struggle by Frank Fitt who was only granted a full licence in 1969 after no less than twelve previously unsuccessful applications.

COVE

Taken from Old English *cofa* and recorded as Coue in 1086, the modern form suggests something other than the real origin of 'the hut or shelter'.

Local pubs include the Tradesmans Arms, now a term applied to retailers it was traditionally used to refer to craftsmen of all kinds. The Snow Goose features a sign

reproducing a famous painting by Peter Scott, who was among the first to bring an awareness of the natural world to everyone, while the Plough and Horses features a typical rural scene.

COWPLAIN

Another quite recent place name, first recorded in 1859 and thus self-explanatory. The Spotted Cow is a pub name which takes advantage of an easily recognised sign, as does the Rainbow.

CRAWLEY

A name found quite often throughout England and almost without exception from Old English *crawe-leah* or 'the woodland clearing frequented by crows'. The name is recorded in 909 as Crawanlea and in 1086 as Crawelie.

The Rack and Manger shows a place where horses could be fed, the rack and manger being receptacles for fodder and hay and a fairly unique name for a pub.

CROFTON

Compared to other places this is a modern parish, although the name is recorded in Domesday exactly as it is today. Undoubtedly this is Old English for 'the croft farm', a croft being a smallholding which may either have been the sole farm here, or possibly a croft allied to the main farm.

Chark is a minor name here, long thought to have a common origin to the Welsh town of Chirk and thus coming from Welsh *carreg* 'rock' or *ceiriog* 'rocky'. However, the modern landscape has nothing to fit this etymology and thus this may be Old English *caert* as found in Surrey and Kent and referring to 'rough common land'.

CRONDALL

Recorded around 880 as Crundellan and in 1086 as Crundele, this name is from Old English *crundel* and speaks of the '(place at) the chalk pits or quarries'.

One minor name here is Swanthorpe, which has nothing to do with water fowl but is 'swains or herdmen's outlying settlement', which is easy to see as alternative pastureland that eventually became a permanent settlement.

CROW

Domesday's listing as Croue points to an old Celtic word *cru*, itself telling us it was where there was 'a fish trap, a weir'. Anyone with knowledge of the baskets and traps used to catch fish at this time will already have a mental image of this place in Saxon times.

CRUX EASTON

A name recorded as Eastun in 801, Estune in 1086 and Eston Croc in 1242. As with all examples of the common place name of Easton it refers to a place which is found east of the main settlement. Being such a common name additions are to be expected, here it is the family of Croc (perhaps Croch), who were here by the eleventh century.

CURBRIDGE

Records of this name would suggest Old English *cweorn-brycg* or 'the bridge of the querns'. However, any suggestion of a bridge made entirely from old millstones is hardly credible, so the reference must be to fewer querns. Perhaps the old millstones were markers on one or both sides, maybe there was just one or two on each side and they kept a firm footing available for foot passengers, or was it simply that this was where someone distributed millstones. We shall never know.

The Horse and Jockey is a common pub name, not always in areas where horse racing is found but possibly named from a former owner or landlord.

CURDRIDGE

Recorded in 901 as Cuthredes hricgae, this is 'the ridge of a man called Cuthraed' and from the Old English personal name and the element *hyycg*.

CHAPTER 4

D

DAMERHAM

Records of this name include Domra hamme around the end of the ninth century and a Dobreham in Domesday. This comes from the Old English *domere-ham* and refers to 'the enclosure of the judges'.

Allenford is a local name which has proven difficult to define. Here the names are found as Elyngford in the fourteenth century and Alyngforde in 1518. It stands on the River Allen but the lack of information probably means this was named from the settlement, a process known as back-formation. It seems likely this is going to be something not unlike 'the ford associated with a man called Ella or Eadla or Aethel', but we will need further examples to be sure.

The local pub is the Compasses, a name often depicted as being the aid to map reading but here it is likely to be heraldic as it appears in the coats of arms of the masons, joiners and carpenters.

DEAN

There are two places with this name in the county, known as East Dean and West Dean, and both are recorded as Dene in Domesday. As with the following name this is from Old English *denu* meaning 'valley'.

DEANE

As has been seen this is a quite common place name, originating in the Old English *denu* meaning 'valley'. It is recorded as Dene in Domesday.

The gap or entrance at one end of the village was marked on maps as *denu-geat* and is where the Deane Gate Inn now stands.

Welcome sign at the edge of Basingstoke and Deane.

DENMEAD

Records of this name are limited to the thirteenth-century record of Denemede, however this is clearly from the Old English *denu-maed* and meaning 'the meadow in the valley'.

The Chairmakers Arms features a sign depicting the coat of arms of that particular trade, one which probably shows that an early landlord or proprietor was associated with chairmaking in some respect.

DEVER, RIVER

A tributary of the River Test, which it meets near Wherwell, is a popular destination for fly fishermen in search of grayling in the winter. The river name is seen as being related to modern Welsh *dwfr* and Celtic *dubro* and meaning, quite simply, 'water'. While this may seem overly simplistic, this is typical of names from the Celtic era, when most simply distinguish it as flowing water.

DIBDEN

The earliest record of this name is from Domesday as Depedene, which comes from Old English *deop-denu* and meaning 'the deep valley'.

DIBDEN PURLIEU

This and the previous place are so close together they could be considered a single place, indeed this may well be how they evolve in the future. The addition is from Middle English *purlewe* and refers to it being 'on the outskirts of the forest'. A quick glance at the map will show it is aptly named as it stands immediately east of the New Forest.

DOGMERSFIELD

Since the early twelfth century, when the name was recorded as Dochemeresfelda, this name has been seen as 'the open land by the dock pool' and a reference to the plant. As the centuries passed the first syllable became Dog-, a predictable corruption.

Minor names here include Pilcot, a name which undoubtedly means 'cottages of the stakes' but is difficult to understand. It would seem to refer to stakes used to mark out an enclosure, but it is unusual to find this type of pallisade around dwellings referred to as cottages. The alternative would be 'the cottages where stakes are obtained' and thus an early lumber supplier.

DOWNTON

Listed as Dunchinton in 1164, Doneketon around 1200, and Doncketon in 1280, this is almost certainly from 'Dunneca's farmstead'. That this has not evolved to Donkton is likely due to Downton in Wiltshire on the opposite side of the New Forest.

DROXFORD

Listed as Drocenesforda in 826 and Deocheneford in Domesday, the suffix is quite clearly a reference to a river crossing. The first element is obscure and the suggestion of Old English *drocen*, while it may fit with the forms, is difficult to see here for it describes 'the dry place'. Now while a ford can easily be dry at certain times of the year, it is not normal to find both descriptions in a place name and thus the origins will remain obscure.

The Hurdles is the local pub, which takes its name from the temporary fences erected for penning sheep. Originally made of wickerwork they were probably stored in a building near this point. In June 1944, D-Day was looming and three of the most powerful men in the world met in a train carriage at the railway station in Droxford. A bench in the village commemorates the occasion when Winston Churchill of Britain,

Dwight Eisenhower of the USA and Charles de Gaulle of France met to discuss this momentous occasion.

DUMMER

Listed as Dumere in 1086, the name is derived from the Old English *dun-mere* and describes 'the pond on or by a hill'.

Chapel Close is derived from the local place of worship, a name coined by developers.

DURLEY

With records of Deorleage in 901 and Derleie in 1086, this is clearly from Old English *deor-leah* and speaks of 'the woodland clearing frequented by deer'.

Wintershill is a local name recorded in 1272 as Wintershull, it comes from Middle English and refers to 'the hill of Winter'. Note this is a family name and nothing to do with the coldest season.

Chapter 5

E

EAST CHOLDERTON

There is no West Cholderton, the only place of this name is Cholderton in neighbouring Wiltshire and that place has a different origin. Here the name is thought to come from a Saxon personal name and Old English *tun*, giving 'the farmstead of a woman called Ceolwaru'.

EASTLEIGH

Even if records such as East lea in 932 and Estleie in 1086 were not available, it would still be easy to see this as from Old English *east-leah* meaning 'the eastern woodland clearing'.

Locally is found the name of Barton Peveril. The 'barley farmstead' is a common place name and thus there is often a second element. Here we find an addition referring to the manor being held by Robert Peverel in 1223.

Former resident Benny Hill is commemorated by Benny Hill Avenue; the Brigadier Gerard public house is named after the famous racehorse retired to stud in 1973; the Arrow is unlikely to have been anything but an easily recognisable sign; the Litten Tree undoubtedly refers to a well-known landmark; the Dog and Crook features the two tools of the shepherd's trade; and the Barge as a pub name is to be expected in a region so tied to the water.

EASTNEY

Just one record of note, as Esteney in 1242. However, this is undoubtedly the '(place at) the east of the island' and derived from the Old English *eastan-eg*.

The statue of the Railwayman, at Eastleigh.

EASTON

This place near Winchester takes its name from somewhere which lay to the west, for the name means 'the east farmstead'. Any suggestion as to which settlement that may have been would be pure speculation. It is recorded as Eastun in 825 and Estune in 1086 and is from Old English *east-tun*.

A local pub is the Chestnut Horse, which shows the animal but is more likely to have come from the horse chestnut tree.

EAST WOODHAY

From 1150 this name is recorded as Wideheia, a name referring to the 'wide enclosure' and coming from Old English *wid-haeg*. The additional East is for distinction from West Woodhay in Berkshire.

ECCHINSWELL

Domesday's Eccleswelle is the sole record of note. This makes defining the name difficult and leaves us with two possible explanations, either this is the '(place at) Eccel's stream' or the first element may be Celtic *egles* and thus give 'the Romano-British Christian church by the stream'.

EGBURY

A name found as Eggeburne in 1184, Eggebur in 1248 and Eggebury in 1284. This comes from the Old English language and tells of 'Ecga's fortified place'.

ELING

From a Saxon personal name followed by Old English *ingas*, and recorded as Edinges in Domesday, this name tells us of 'the settlement of the family or followers of a man called Eadla or Aethel'.

ELLINGHAM

There is a clear similarity between this and the previous name, this is reflected in its origins of 'the homestead of the family or followers of Aethel'. However, there is little in common between the two records in Domesday, where this is shown as Adelingeham. Despite the similarities there is nothing to suggest it refers to the same person, indeed they are too far apart for this to be considered.

A region to the east of Ellingham is known as Rockford and has existed since at least the time of Domesday towards the end of the eleventh century. The name has several forms which appear to have two or more potential origins, yet there is every chance this is simply that the name was misunderstood and the name remembers this as 'the rooks' ford'. However there is every chance this could represent a personal name.

Broomy Walk is not seen before 1787, but it seems likely that this was coined many years earlier. Whether this is from Old English *brom-leah* 'the woodland clearing where broom grows' or *brom-hyll* 'the hill where broom grows' is unclear.

One local at Ellingham is the Alice Lisle. A lady of some influence during the seventeenth century, Dame Alice Lisle was executed for hiding fugitives from the Battle of Sedgemoor. On the night of 20 July 1685, John Hickes and Richard Nelthorpe were given shelter at Moyles Court and the following day all three were arrested. She was tried in front of Judge Jeffreys at the infamous Bloody Assizes in Winchester. Jeffreys sentenced her to be burned that very afternoon, but relented and gave her a few days to prepare, by which time James II had allowed beheading instead of burning. The sentence was carried out in Winchester market place on 2 September 1685, and a plaque marks the spot.

ELLISFIELD

Recorded as Esewelle in 1086 and Elsefeld in 1167, this name comes from the Old English describing 'Ielfsa's open land'.

ELVETHAM

Recorded in 712 as Elfteham, as aet Ylfethamme in 973, and Elveteham in Domesday, this name is undoubtedly 'the hamm of the swans'. It is the Old English *hamm* which is uncertain for it has several meanings, although with similar descriptive terms. It was always thought to refer to a 'water meadow', whereas today the explanation would be a more general idea of a region virtually cut off by natural barriers – such as a promontory, a cleft in a cliff, or, as here, a fork in a river. It is easy to imagine the serene Saxon scene.

Locally we find Hartford Bridge, which was originally 'the ford frequented by harts or stags' which was eventually replaced by the bridge now seen in the place name.

EMERY DOWN

A name not seen before 1376, when it appears as Emerichdon with Emeryesdowne at the end of the fifteenth century. As a place name it comes from a Germanic personal name, the same source as Saxon personal names yet the route it took to reach here was by no means as direct as other Old English place names. We know this name comes from the Norman French landlords the Emmory family, who were here by 1389, yet their ancestry and their name is itself a Germanic male name and probably travelled out to France with the advancing Roman Empire.

EMPSHOTT

Records of Hibesete in 1086 and Himbeset in 1170 show this to be from Old English *imbe-sceat* and telling us of 'the corner of land frequented by bees'.

EMSWORTH

The early thirteenth-century record of Emeleswurth points to this coming from 'Aemele's enclosure'.

Locally the name of New Brighton did not take its name until 1805 when Princess Amelia came to take the waters. Here is the link to Brighton in Sussex, a place associated with the Prince Regent and the basis for the place name.

Local pubs include the Coal Exchange, once the place where merchants met to sell or buy the fossil fuel; the Round Table is named after King Arthur's Round Table hanging in the Great Hall at Winchester; the Good Intent takes the name of an in-shore naval cutter used to defend the coastline during the Napoleonic Wars; the Bluebell is a common

name and always refers to the close proximity of the church; and the Lord Raglan is named after the Somerset family who took their title from Raglan in Monmouthshire.

ENBORNE (RIVER)

It is unusual to find a river name which has been confused with another river name, usually they would fall in the same system and be seen to run together – both in a physical sense and etymologically speaking. Here is a river name recorded as Aleburnan in 749, Alerburnan in 931 and in the thirteenth century as Aneburne. It is this most recent record, still seen in the modern form, which has been confused with the village of Enborne in Berkshire and a name which means 'the duck stream'. While there may have always been ducks on the surface of the Hampshire river the earlier forms show the name has nothing to do with water fowl but refers to what was found along the banks, for this is 'the stream of the alder trees'.

This definition is different to most river names, for the vast majority refer to flowing water – be it strong, loud, slow, dark, or simply a river or stream. Even the Berkshire version refers to the water indirectly, in the form of the wildlife, with ducks quite likely to be seen anywhere along its course. When, as here, the name refers to what is on the river banks, in this case alder trees, it is almost impossible to think the entire length of this river (and on both banks) was lined by such trees. Thus the name must have been relevant to a specific point on that river and therefore that is where the name came from and that the name is recorded as such is pure chance, elsewhere along the river the name must have been different because there were no alder trees.

ENHAM ALAMEIN

A most unique name and a quite recent one. Listed in Domesday as Etham, this comes from the Old English *ean-ham* and describes 'the homestead where lambs are reared'. By 1389 the name had evolved to Knyghtesenham, referring to the knight's fee held here by Matthew de Columbers at this time. At the end of the Second World War the place was renamed to commemorate the Battle of El Alamein, a reference to the centre for disabled ex-servicemen here.

EVERSLEY

Records of Euereslea and Evreslet in the eleventh century point to one of two potential origins. Either this is 'the woodland clearing where boar are seen' or 'Eofor's woodland clearing'. Without further evidence it seems unlikely if it will be resolved.

Local pubs here include the Chequers, named after the game which was once played in Roman taverns and which came to symbolise a moneylender; the Golden Pot, most likely taken from a simple sign; and the Frog and Wicket, formerly called the Cross and before that the Toad and Stumps and a clear cricketing reference, albeit an unusual one.

EVERTON

A small village near Lymington which takes its name from 'the farmstead on the River Gifl'. The evolution from Gifltun to Everton came via Iveletona in 1272, Ivelton in 1346, Yevelton in 1646 and Evelton in 1810.

EWSHOT

A name found in the thirteenth century as Hyweshate, Yweset and Iweshate and from the Old English 'the yew sceat'. *Sceat* is an element referring to 'a corner of land' and this region does indeed jut into neighbouring Surrey.

EXBURY

This place is derived from 'the fortified place of a man called Eohhere'. However, it is only thanks to those knowledgeable in the evolution and nuances of English and its various dialects that this personal name can be seen in records such as Domesday's Teocreberie and as Ykeresbirie in 1196.

Minor names here include Lepe, from Old English *hliep* and describing where a fence was constructed around a grazing area trapping domesticated animals but allowing deer to jump the barrier. Gatewood is a name recorded as Gatewod in 1235, a name which comes from *gata-wudu* or 'the wood where goats are seen'.

EXTON

From the Old English *Eastseaxe-tun* and recorded as East Seanatuen in 940 and Essessentune in 1086, this place began life as 'the farmstead of the East Saxons'.

Lomer is a minor name which has been applied to a farm, a road and, in the modern era, a group of cottages. It began life as 'the loam pond' and is found as early as the ninth century. There is a hillfort here which has somehow acquired the name of Old Winchester Hill, despite there being no record of any association with Winchester past or present, indeed there is no record of any name for this place since a pre-Conquest record of 'the gate to the earth fort'. Such a reference would be expected to produce a name not unlike 'Burgate', yet with no recorded name it seems a creative cartographer decided a name was required and filled in a gap, much the same as was the case with unknown regions on land and sea where they would have declared 'here be dragons' simply to fill a gap.

EYEWORTH

Recorded as Iuare in 1086 and in Iware in 1365, this name is derived from Old English *iw-waru* or 'the yew tree weir'. This almost certainly refers to a weir erected to retain fish in the pond here.

CHAPTER 6

F

FACCOMBE

Records of Faccancumb in 863 and Facumbe in 1086 show this to be from Old English *cumb* preceded by a personal name. Here we have the '(place at) Facca's valley'.

Minor names here include Netherton, referring to 'the lower farmstead' although there is no 'upper' for this is effectively Faccombe itself.

FAIR OAK

The name is first seen in 1596 as Fereoke and, as the modern form suggests, really does refer to the '(place at) the beautiful oak'. Furthermore we even know the tree in question was felled in 1843 and a new tree planted in its place, which still stands today.

FAREHAM

From Old English *fearn-ham*, this is 'the homestead where the ferns grow'. Early listings of this name show the meaning and origins quite clearly, as seen in such records as Fernham in Domesday and Fearnham in 970.

Alice Holt Forest was once quite extensive. However, today, aside from isolated trees, the forest is no more. The name remains, as it did in the twelfth century as Alsiholt, Alfsiholt and Alsiesholt. This name is dervived from 'the managed woodland of Aelfsige'. A Saxon holt has been said to be a woodland formed almost exclusively from one species of tree. In a forest of this size, however, there would have been many, many holts. One such example has the name of Bucks Horn Oak, which would have been even more specific and referred to a single tree with branches reminiscent of the same.

Cams Hall is found in 1242 as Kamays, in 1248 as Kamuse, in 1259 as Kamus, in 1268 as Cameys and in 1280 as Cames. This place name comes from an early British *cambes*, related to Welsh *cemaes* and from British *cambo* meaning 'crooked', a reference to a well-

Looking from the church of St Peter an St Paul's, through Fareham, along Osborn Road.

defined bend in the Wallington River. Further evidence is seen in neighbouring Wallington, where the very name tells us there were Welsh speakers here during the Saxon era.

Street names of Fareham include Hartlands Road, which was formerly called Blinds Lane and all that is known about these names historically is that it led to the cricket field. Bath Lane was previously Bathing House Lane, the site of the public baths. Highlands Road was changed deliberately, for it was thought that Frosthale Road suggested it was cold when the reference is actually to a personal name.

To the west of the town is West Street, formerly known as Charles Street after developer Charles Osborn who is still remembered by Osborn Road. What is now East Street was previously Bridgefoot Hill, which is also the destination. Whilst East and West Street have come to the town, the other primary compass points have vanished. North Street is now known as High Street and was home to the Cheese Fair until 1871, while South Street later became Quay Lane and is now Quay Street for predictable reasons.

What is now Mill Lane was formerly Windmill Lane, however since the loss of the windmill the name has shortened accordingly. The name of Peak Lane is an error, while there was no formal change of name it was once Peat Lane and was the route taken to gather fuel. Finally there is Russells Place, taken from an old resident and replacing the name of another who called Fareham home. Its previous name is a surname which is rarely seen today, although it is hardly surprising when learning this was once known as Bastards Yard.

Fareham is twinned with the French town Vannes, which takes its name from the River Vannes which means simply 'white'.

Public houses in Fareham take their names from a wide range of sources. The Sir Joseph Paxton remembers the nineteenth-century gardener and architect best known for designing the huge glass exhibition hall known as the Crystal Palace. Lord Arthur

Lee is not just the name of a pub, he was the 1st Viscount of Fareham. The Wicor Mill displays an image of the windmill which is found at Wicor. The Castle in the Air suggests this pub was the stuff of dreams; the Hampshire Rose, a simple but decorative sign; the Turnpike reminds us a toll was once paid to pass by here; while the Cob and Pen are the names of the male and female swan.

With the sea nearby, the names of some pubs were certain to have a nautical theme. The Admiral or the Buccaneer are easy to see, but maybe not the Brass Monkey which probably only brings to mind the phrase 'Cold enough to freeze the balls off a brass monkey', and indeed this is where the nautical theme comes in. In days of old when the might of the British Empire was based on the strength of its navy, the ships were armed with innumerable cannon firing cannonballs. Before being loaded the cannonballs were loaded in a pyramid shape onto a brass tray, known as a brass monkey. On the coldest of days freezing temperatures caused the metal to contract. Iron cannonballs expand or contract to a much smaller degree than brass and thus at low enough temperatures the brass monkey would contract and spill the cannonballs – hence the expression.

FARLEIGH CHAMBERLAYNE

Found in Domesday as Ferlege and in 1212 as Ferley, the basic name is derived from Old English *fern-leah* or 'the woodland clearing where ferns grow'. Here the addition reminds us that the manor was held by the Chaumberleyn family by the twelfth century, as seen by the records of Ferlega Camerarii in 1167 and Farlegh Chaumberlayn in 1297.

Minor names here include Slackstead, a name found in 903 as Slastede, in 1269 as Slacstede and in 1350 as Slaghstede – 'the place where blackthorn sloes can be collected'.

FARLEIGH WALLOP

Recorded as Ferlege in Domesday, the name comes from the Old English *fearn-leah* meaning 'the woodland clearing overgrown with ferns'. The addition, referring to the Wallop family who were here by the fourteenth century, is required to distinguish between this and at least five others in the southern counties of England.

FARNBOROUGH

Found in Domesday as Ferneberga, this is clearly Old English *fearn-beorg* or 'the hill overgrown with ferns'.

Locally we find Rafborough, a name which would appear to be similar to that of the town and this was deliberate. The town has been associated with the flight for almost as long as men have taken to the skies. This region took the suffix *-beorg* or *-borough* and added the initials of the RAF for the first element. Clearly as the RAF did not exist until after the First World War the place name could not have existed until the twentieth century.

Fox Lane here is derived from the former name of Foxlease Farm which the lane served. The name of the farm comes from a surname, a former tenant.

The names of public houses are often recognisable as they have two quite unrelated elements. Who would think of the Lamb & Flag, Pig & Whistle or Dog & Doublet as anything but a public house? These examples are among the most common and all can be explained, yet this trend was copied for names which have no etymological value for names such as the Slug & Lettuce and, here in Farnborough, the Ham & Blackbird which is simply two quite unrelated items being put together to form a name which cannot be anything but the name of a pub. To a lesser degree the same could be said about the Crab & Anchor, although there is a link to the sea.

Historically trees were chosen for pub names as they provided a marker whose duration, in comparasion to a human lifespan, was seemingly permanent. This trend was copied more recently to point to the Chilean pine which stood outside one local in Farnborough. Few will have heard of the Chilean pine for it is better known by another name, although it is not used outside Britain. When botanist Archibald Menzies first brought the tree to England in 1796 he remarked that the twisted branches and spikes, which are in reality the leaves, would prove a real puzzle for any monkey trying to climb it. Hence the pub is not referred to as the Chilean pine but the Monkey Puzzle.

FARRINGDON

Listed as Ferendone in Domesday, this comes from the Old English *fearn-dun* and tells us this was once simply 'the fern covered hill'.

FAWLEY

Much of what we know about the older unwritten languages is based on comparisons with known languages and an understanding of the evolution of names. This is particularly so when records of a particular place name are few or confusing. Fawley is one example of the only two that we have from Domesday. As explained in the introduction, this is a most unreliable source of names and furthermore those records from 1086 are different, Falegia and Falelei.

There are three other places named Fawley, all in the southern half of England, and each has a different first element with the suffix *leah* and thus three different meanings. With few early listings it is difficult to know where this name comes from, and thus there are two equally plausible meanings for this name. If this is *fealu-leah* it would describe 'the fallow-coloured woodland clearing', or if this is *fealg-leah* it would point to 'the ploughed land in the woodland clearing'. Of course, it is just as likely that without ploughing the land could not have been described as exhibiting such a colour and therefore could well have alternated between the two, albeit not deliberately.

A region here is known as Buttsash, a name which first appeared in 1212 as Bottesesse, as Bottesasshe in 1269 and as Butesasse in 1280. This is from the Middle English for 'the ash tree of the But family' perhaps referring to a William le But who was living here in 1327. This same family gave a name to Butts Bridge here. Langley is a common name, the district here describing 'the long woodland clearing'. Stone is a name which

appears to mark the old Roman road which terminated here, probably once marked by a prominent stone. Stanswood is mentioned in Domesday, somewhat earlier than the previous name but one which takes its name from that place as being 'Stone's wood'. Rollstone is recorded as Rolveston and Rotheleston in the thirteenth and fourteenth centuries respectively, the name referring to 'Hrothwulf's farmstead'.

FINCHDEAN

Early forms for this name are limited to Finchesdene in 1167 and Finchesden in 1248. It is probably a Saxon personal name and 'Finc's valley' although it is possible this is simply 'the valley where finches proliferate'.

FLEET

From Old English *fleot*, describing the '(place at) the stream, pool, or creek', the name is not recorded until 1313 as Flete.

Pubs here include the Hog's Head, not the pig but a size of barrel or cask first standardised in 1423 although the volume has been altered several times since; the Oatsheaf, which has an agricultural theme, an alternative to the normal sheaf of wheat or barley although it was probably difficult for the ordinary man to discern between the three; and the Prince Arthur, named after the third son of Queen Victoria, Arthur William Patrick Albert (1850-1942) who was Duke of Connaught and Earl of Sussex.

FORDINGBRIDGE

Domesday's record of Fordingebrige is more like the modern form than the original Saxon *ford-inga-brycg*, telling us it was 'the bridge of the people living by the ford'. Logically the ford existed before the bridge, probably even before the settlement.

To the east across the Avon is the old place name of Criddlestyle. It is quite common to find the first element in a place name to be uncertain, however here the reverse is the case with the first part the Saxon personal name Cridel. The suffix could be seen to be Old English *tun* 'farmstead', *stowe* which is often simply 'place', *treow* meaning 'tree', and *trog* or 'trough'. The Avon here runs in several channels, both natural and man-made, thus it is tempting to suggest the last of these is the origin giving 'Cridel's water conduit' although further examples would be required to be certain.

Two street names in Fordingbridge come from very different but certainly most interesting origins. The Hundred is said to have taken its name from a house which stood near the bridge here and which had 100 windows which afforded lovely views towards the river. The name of Horseport was taken for the road from the doctor's premises, now longer standing. Earlier still this is thought to be where horses were unloaded from barges on the river to be sold, or perhaps this was simply where horses would wait to haul unloaded goods up away from the riverbank. Midgham is recorded

as Migham in the twelfth century and is a name which refers to the 'midge water meadow' – a less-than-inviting place name.

Pubs here include the Fighting Cocks, a name pointing to the location of a pit where specially bred cockerels, equipped with metal spurs, would battle to death while vast amounts of money were wagered on the outcome. The sport was outlawed in the mid-nineteenth century but continued for some time afterwards. The name of the Augustus John is taken from the etcher, painter and lecturer Augustus Edwin John (1878-1961). He painted portraits of some very famous people, including politician Lloyd George, wordsmith George Bernard Shaw and soldier Lawrence of Arabia.

FORTON

A common place name and one which is recorded exactly as in the modern form since it is first seen in 1312. It comes from the Old English *ford-tun* which, as is the case with all common names, has a very simple meaning. Here it is 'the farmstead by the ford'.

FOUR MARKS

First found at a comparatively late date, in 1548, as Fowremerkes. The second element here is Old English *mearc* meaning 'boundary'. Together they tell us this was where four ancient parish boundaries met.

FOXCOTTE

A name recorded as Foxcote in 1146 and Foscote in 1431, this is certainly 'the fox cottages' although it might be better to interpret it as 'the fox earths'.

FRATTON

Recorded as Frodincgtune in 982 and Frodinton in 1086, here a personal name is followed by Old English *ing-tun* and tells us it was 'the farmstead of a man called Froda'.

The Connaught Arms is named after Prince Arthur, third son of Queen Victoria, the Duke of Connaught. The Electric Arms is a name which came with the advent of the electric light in the nineteenth century.

FREEFOLK

Lying north of the River Test this delightful village really does derive its name from '(the place of) the free folk' from Old English *freo-folc*. It is the only town or village name in England with this as a second element, indeed it is only seen elsewhere in the counties of Norfolk and Suffolk. The meaning might be clear, but understanding it is another case entirely for it is not recorded as being exempt from rent or taxation.

The delightful terrace of thatched cottages at Freefolk.

The local pub is today called the Watership Down, built in 1840. It was previously known as the Freefolk Arms and took its change of name from the Down near here which had been chosen as the setting for Richard Adam's famous book of that name – the one about the rabbits. What is not clear is why the locals refer to this pub as the Jerry.

FRENCHMOOR

A name found in the thirteenth century as Freschemore and as Frenshemore and is telling us it was 'the French moor' as the modern form suggests. It seems this most likely refers to a family name rather than the nation, although ultimately this would have been the origins of the surname.

FRITHAM

A name from Old English *fyhth-hamm* meaning 'the enclosure in sparse woodland'. It is first recorded as Friham in 1212.

FROGMORE

The earliest record of this name is dated 1294, when it appears exactly as it does today. This is from the Old English *frogga-mere* or 'the pool frequented by frogs'. This hardly

seems a name showing any distinctive qualities, as most pools have frogs. Thus it is more likely to tell that fish were absent and not a place where food may be acquired, hence it may possibly be seen as a derogatory term prior to settlement.

FROXFIELD

As with the previous name, this 'field frequented by frogs' from Old English *frosc-feld*, was probably coined long before any settlement arrived and used as a derogatory term to describe a field which was likely to remain overly wet and thus poor farmland, but ideal for amphibians. It is first recorded in the tenth century, by which time there was a settlement here, as Froxafelda.

Minor names include Oakshott from Old English *ac-sceat* or 'the oak tree corner'. The local is the Trooper Inn, a term used for a soldier from the early seventeenth century to describe a part of a group of cavalry. The word is taken from Latin *troppus* meaning 'a flock'.

FROYLE (UPPER & LOWER)

The two Froyles have obvious origins in relation to one another, albeit the ridge on which Upper Froyle stands is difficult to see. The basic name has been suggested as referring to the 'hill of Freo or Frig', where the personal name refers to pagan god. However, this does not fit with the early forms of Froli, Froila, Froyle and Frohill. Taking both the topographical and etymological discrepancies into account, it may be that any idea of a 'hill' is the problem and the two elements here are both watery references. This would refer to the River Wey, a name discussed under its own entry, and a place name which comes from *frow-wielle* which is the '(place at) the swift stream'.

Another settlement which produces a triangular shape with the two Froyles is Coldrey. This name is undoubtedly 'the charcoal stream' but just what message this is conveying is unclear. It may be telling us it was 'the stream where charcoal is made on the far side', i.e. the opposite side to the settlement, or if we can trust a record hinting at the possibility of iron smelting going on near here then this is the reason for the charcoal being produced here.

FULLERTON

First found in Domesday as Fugelerestune, this name comes from Old English *fuglere-tun* or 'the farmstead of the fowlers or bird catchers'. Clearly this was a source of birds of many varieties for the table, reared for that specific purpose and having their wings clipped to prevent escape.

FYFIELD

A name first found in 975 as Fifhidon and later as Fifhide in Domesday, this name comes from the Old English *fif-hid* telling us it was 'the estate of five hides'. A hide is

often misquoted as being a measurement of land, but it is impossible to quantify in acres or hectares for it could vary wildly. To the Saxons and Norsemen an area of land – be it a hide, virgate, carucate, bovater, ox-gang, sulung or yoke – was based on the amount of land which could be worked by a ploughmen and his oxen in a single season.

For racegoers the term furlong will be well known, although for the younger generation who have only ever worked in a metric system it will be difficult to envisage. A furlong was defined as 220 yards, equal to 201.168 metres, and was said to be the distance a team of oxen could pull a plough before requiring a rest, literally a 'long furrow'. Clearly the distance travelled before a rest depended on a number of other factors, the quality of the soil, number and size of stones, how overgrown the place was prior to clearing and thus the root systems below ground level, the moisture content, how tired the animals and the men were, indeed the distance was only a minor factor and could differ greatly. As a result a hide could have been any size and, although often said to equate to approximately 30 acres (12.14 hectares), this is only an average and should be viewed as such.

CHAPTER 7

G

GODSHILL

A name recorded in 1230 as Godeshull and which is derived from Old English *god-hyll*, means exactly what it seems. However, by the date of the original settlement, the true meaning is clouded, for either this is a Christian site or an earlier heathen god is being referred to.

A six-mile circular walk which traditionally starts and ends in Godshill takes in some of the finest aspects of the New Forest. It is not a modern creation but is recorded as early as 1670, although it would not have followed the same route. The name refers to this walk being through the 'ash wood'.

The local is the Griffin, a pub which has a maze to entertain children laid out in the shape of a griffin, a beast used often in heraldry as it was said to possess the noblest attributes of the lion and eagle from which it was descended.

GOODWORTH CLATFORD

Originally this place was recorded as Godorde in Domesday. Later seen as simply Goodworth, derived from Old English for 'Goda's enclosure'. The name seems to have assimilated that of Clatford because that place has acquired the addition as Upper Clatford. Either the addition of 'upper' was a clerical error (such mistakes are not unheard of) or there was another Clatford which has since disappeared.

GOSPORT

An ancient and natural port which has long been settled by humans. Over the centuries the place must have been a destination for many travellers, both overland as well as by sea. One of the later reasons for coming here is revealed by the name of the place which, derived from the Old English *gos-port*, speaks of 'the market town where geese are sold'.

Obviously this is a food item and much sought-after for it provided more meat than other birds, as turkeys were unknown in Saxon England.

Locally the name of Brockhurst features two common Old English elements *broc-hyrst* and tells of 'the wooded hill by the brook'. However, in neighbouring Sussex and nearby Kent similar names have evolved from 'marshland by the water' and this may well be the meaning here for this definition certainly fits the description of the area much more closely. Camdentown was named around 1800, undoubtedly taken from the London place name and commemorates the first Earl Camden. He, in turn, took his title from Camden Place of Chislehurst, Kent which is derived from William Camden the sixteenth-century antiquarian who penned the first topographical survey of the British Isles.

Street names of Gosport reflect the history of the town, although not always from the obvious source. For example, Seahorse Street is not named for the instantly recognisable fish, but from the public house here which took this name. Crossland Drive stands where the funeral directors run by Edward Crossland was once a familiar sight. Minnitt Road takes the name of lifelong resident Francis Minnitt, a popular cartoonist whose family have lived in Gosport since the middle of the nineteenth century.

Jellicoe Avenue is one of the names taken from the naval associations of the town. Admiral of the Fleet John Rushworth Jellicoe, 1st Earl Jellicoe (1959-1935), is best remembered for his role as commander of the fleet at the Battle of Jutland in the First World War. The engagement began on 31 May 1916, and by the end of 1 June combined losses of 8,645 dead and vessels totalling over 175,000 tons saw both sides claiming victory. As the British losses were more than double those of the German fleet,

Views across the lake at Gosport towards the harbour.

Named after one of Gosport's residents who made his living as a cartoonist.

Jellicoe's purported success was deemed a hollow victory at home. The British press were particularly vociferous in their criticism, and it is true to say that the argument continues to this day.

Councils have a tendency to go for inoffensive names and on the Rowner Naval Estates the suggestions were typically bland – themes of birds, animals and trees. However, the Post Office has the power of veto, and the last thing the Royal Mail wants is potential confusion over street names. They pointed out such names were already in existence. The argument raged back and forth, and even residents, who by now have moved into (officially) nameless roads, were involved. Eventually the residents won the battle and cathedral cities were chosen for Derby Court, Bristol Court, Worcester Court and Truro Court.

While the naval link to the sea is clear, it is often forgotten that in the twentieth century the air also became an important consideration for the Royal Navy. Hence the choice of the closes remembering famous aerial names; Pegasus Close (the winged horse of Greek mythology and a name adopted by several aircraft since), Otter Close (de Havilland produced at least two aircraft of this name), and Gazelle Close (the Gazelle is a French-designed helicopter). Cochrane Close reminds us of Jacqueline Cochran (1906-80), who was one of the most gifted pilots of her generation, or possibly John Cochrane who test-flew all British-built Concordes. Davenport Close points to either the Canadian manufacturers or the British pilot and Lindbergh Close reminds us that Charles Lindbergh was the first person to fly the Atlantic Ocean solo. Balfour Close is named after Harold Harington Balfor, 1st Baron Balfour of Inchtye, Conservative politican and First World War flying ace. Finally, Napier Close was named after Napier & Son, who produced engines for aircraft from the Second World War onwards.

For many years Syd Ashby had campaigned for the many old street names of Gosport to make a return. Since 1931 Syd had worked in Milletts in the High Street and to commemorate his fifty years service for one company the council brought back the name of Ashby Place to Gosport. However, this was not named after his family, as, coincedentally, this is also an old place name.

Local pubs include the Gypsy Queen, named for Margaret Finch. She was known as the Queen of the Gypsies and died in 1740, reputedly the year of her 109th birthday. The Cocked Hat was probably chosen as an alternative to the normal names given to coaching inns. The sign displays an image of the tricorn, a three-sided hat with upturned brim which sent rainwater away from the wearer. The Carisbrooke Arms is named to commemorate Alexander Mountbatten, the 1st Marquis of Carisbrooke who was the father of Lord Louis Mountbatten. The Five Alls is a name normally confined to the West Country but is starting to spread elsewhere. The sign shows five people. The king states 'I rule for all', the priest 'I pray for all', the lawyer 'will plead for all', the soldier promises to 'fight for all', while the labourer 'works for all'.

The Clarence Tavern is named after Prince Albert Victor, Duke of Clarence and eldest son of the man who would become Edward VII. The only reason he did not accede to the throne was his premature death at the age of twenty-eight in 1892, a few short weeks after his engagement to Mary of Teck. While he never became king, his betrothed, Mary, did become queen for she was engaged to his younger brother George just a year later. Conspiracy theories have surrounding the death of the Duke of Clarence, involving speculation about his intellect, his sanity, and even his sexuality to the point where it was suggested he was linked to a scandal involving a homosexual brothel. Authors have even gone to great lengths to show how he was the serial killer Jack the Ripper. However, documents show he could not have been anywhere near London at the time of the murders, while evidence of his sexual preferences are by no means conclusive.

GRATELY

Listed as Greatteleiam in 929, this comes from *great-leah*, an Old English term meaning 'the great woodland clearing'.

Two local pubs, the Plough Inn and the Shire Horse, are named for the still agrarian community and complement each other nicely.

GRAYSHOTT

From the Old English *graf-sceat* is 'the corner of land near a grove', first recorded as Grauesseta in 1185.

GREATHAM

Domesday lists this place as Greteham, itself from Old English *greot-ham* and telling us 'the gravelly homestead' must have been difficult to farm.

GREYWELL

A name of Old English origin in *graeg-wella* or 'the spring or stream frequented by wolves'. The first name of this record dates from 1167. It must, however, have been in use many years before this, possibly even from the time the Saxons first walked the lands around here. In the latter half of the twelfth century, the date of the earliest surviving record, wolves must have been very rare indeed here. Evidence of this comes from 1212, when a document shows a bounty of five shillings was paid to a person near Kingsclere for a wolf caught there, a place only ten miles away from Greywell. Such an enormous sum is an unprecedented amount to be paid for the body of a wolf, even considering the skin of the animal was very highly prized. This tells us that by the early thirteenth century the wolf was a very rare creature indeed. Records show it was extinct by 1680 and would have only held on in the most remote corners of the island for much of the interim period. Logically, the name existed well before the twelfth century and it should not be discounted as a personal name, or a nickname.

The Fox & Goose is a pub name which always depicts images of those animals on its sign. Yet the origins of many must be the game called Fox and Geese, a variation of Nine Men's Morris, and would have been played within the pub. Played since Roman times, this is a board game played on a chequer board and resembles the modern game of draughts. It has almost as many variations in rules as there are pubs called the Fox and Goose.

CHAPTER 8

H

HALE

A common place name, this example was recorded as Hala in 1161. It comes from Old English *halh* and describes the '(place at) the corner of land'.

HAMBLE

Originally this place was recorded as Hamele in 1165. Undoubtedly this comes from Old English *hamel-ea* and describes 'the river with bends in it', which has become known as the River Hamble.

Local names include Satchell, a rather shortened modern form of 'Sceott's nook of land' and seen as Sotteshale in 1251, Shotshall in 1548, Shaltshall in 1586 and Shotshall alias Satchell in 1766. These are written evidence of the old name and the newer version being in existence at the same time, effectively two slightly different pronunciations of the same name.

HAMBLEDON

Despite the similarity with the previous name this place name has a completely different meaning. Together, they are an excellent example of why as many early forms of the name are required as it is possible to find. From 956 we find Hamelandunae and in Domesday Hamledune, which points to Old English *hamel-dun* and describing 'the crooked hill'.

Bittles Farm takes its name from Buttevileyn, a manorial name which probably started off as a nickname.

Locally we find World's End, a name coined on numerous occasions during the eighteenth and nineteenth centuries when the British Empire was expanding and reports

of many places came back which must have seemed at the end of the world to the people of England. Thus the farthest and most remote corner of a parish became so named.

Here is Broad Halfpenny Down, claimed to be where the game of cricket was born and is commemorated by the Bat and Ball public house. This place name has only one early listing, from 1647, which is exactly the same as today's. While, on one hand, this broad expanse is aptly and quite clearly named, the second element is something of a mystery for the form is rather late. However, the mention of money is invariably a reference to rent or sometimes, in the case of tiny amounts, a derogatory comment on the quality or return of the land.

HAMPSHIRE

The name is first found in a document of the late ninth century as Hamtunscir. This refers to 'the district based on Hamtun', with the place name being a shortened form of Southampton and Old English *scir*, an ancient administrative district.

HANNINGTON

A place name first found in 1023 as Hanningtun, while Domesday gives it as Hanitune. This is composed of a Saxon personal name suffixed by Old English *ing-tun* and meaning 'the farmstead associated with a man called Hana'.

HARBRIDGE

A name found in 1086 as Herdebrige, in 1236 as Hardebrigge and in 1248 as Hardingebrigge, this recalls this was 'Hearda's bridge'. Records show that the population of today's village is smaller than in the thirteenth century.

HARDLEY

From the Old English *heard-leah* the '(place at) the hard clearing', and is first recorded as Hardelie in 1086. This most likely suggests the place was difficult to work, possibly a tough soil to plough because of old root systems or stones.

HAREWOOD FOREST

The record from 1198 would point to this being Old English *haran-wudu* or 'the wood where hares are hunted'. However, another record shortly afterwards in 1238 would change the thinking to *hor-wudu* or 'the hoar wood' where the first element refers to it being 'grey, lichen-covered'.

HARTLEY MAUDITT

Recorded as Herlege in 1086, Hertlie in 1212, and Hurtlye in 1242 this is, along with the following names, 'the woodland clearing frequented by stags'. To distinguish this name from the others the name of the thirteenth-century landlord of William Maudoit is added.

HARTLEY WESTPALL

A name found as simply Harlei in 1086 which has, by 1270, become Herlegh Waspayl. The basic name is derived from Old English *heorot-leah* and meaning 'the woodland clearing frequented by harts or stags'. To this was added the name of the lords of the manor from at least the thirteenth century, the Waspail family.

HARTLEY WINTNEY

As with the previous name this is 'the woodland clearing frequented by harts or stags'. Here the addition comes from its ownership by the Priory of Wintney by the thirteenth century. This name is found as Hurtlege in the twelfth century and Hertleye Wynteneye in the thirteenth century.

One district here first appeared in 1826 as Phoenix Green. The name has persisted until the present and is derived from the inn which stood here. The local name of Stapely is found as Stapeleg in 1184, Stapeleya in 1201, and Stapelleg in 1206 and comes from Old English *stapol-leah* or 'post woodland clearing'. This is understood to refer to a place where posts were prepared and/or stored, rather than somewhere marked by posts.

The local pub is the Waggon and Horses, marking a place where goods were left as inns acted as agents at a time before the railways and even canals. Later, the horse-drawn waggons brought farm produce over shorter distances. It has often been said that the pub name is wrongly spelt. If one looks at old copies of the *Oxford English Dictionary*, it can be seen that waggon is the preferred and 'British' spelling.

HASLAR

That part of Gosport which juts out toward Portsmouth takes its name from Old English *haesel-ord* and refers to 'the point where hazel trees grow'.

HATHERDEN

A name of Old English origin in *hagu-thron-denu* and meaning 'the valley of the hawthorn'. The earliest record of this name comes from 1193 as Hetherden.

For any pub it was important to be an important part of the community, particularly in early days when all trade was local. As many were religious and/or passionate about their nation, showing allegiance to the church and the monarch was a good selling point – hence the origin of the name of the Old Bell & Crown.

HATTINGLEY

Not seen until 1204 as Hattingele, this name comes from the Old English combination *haett-ing-leah* and means 'the woodland clearing of the hill place'.

HAVANT

Records of this name date back to 935 as Hamanfuntan, while Domesday gives it as Havehunte. Here a Saxon personal name and the Old English *funta* combine to tell us it was once recognised as 'the spring of a man called Hama'. Unlike Old English *wella*, which can refer to a stream more often than a spring, *funta* refers specifically to where the water gushes from the earth and is related to the modern 'fountain' as well as, and more recognisably than, the second syllable in the modern place name.

A district near the shore has the name Brockhampton, found in Domesday in 1086 and in the modern form as early as 1236. This speaks of 'the farmstead of the dwellers on the brook'. Leigh is a common name, from *leah* or 'woodland clearing'.

Barons Arch and Bartons Road take the name of the Barton family and, in particular, Revd Matthew Barton who founded the Havant House Academy Boarding School for Young Gentlemen. Beechworth Road was previously Station Road, and as the railway no longer runs nearby the council changed the name to avoid confusion. The new name does not contain any historical references to the local area. Bellair Road is named after the house of this name that still occupies a place in this road, just as Montgomery House gave a name to Montgomery Road.

Two roads are indirectly named from the Hampshire Regiment. They were cut on land owned by Colonel F. Stubington, a member of the regiment. When founded, the regiment was known as the Duke of Connaught's Own and were based at Oaklands, hence the names of Connaught Road and Oaklands Road.

Fitzwygram Crescent commemorates General Sir Frederick Fitzwygram, MP, JP, and the last effective lord of the manor. In his will he left his home, Leigh Park House, and its lake and gardens to the people of Havant for their recreation and enjoyment. When the farmland and orchards of brothers Richard and William Softly were developed they took names from features in the family's lands in Grove Road and Orchard Road.

The Pallant is a region linked to Latin *paladium* and indicating a bishop's house and possession by the bishops of Winchester. Rectory Road was once the site of the old rectory. Shadwell Road is a corruption of St Chad's Well, named after the Bishop of Mercia and the Nothumbrians who died in March 672.

Kingscroft Lane was where Edward I camped in 1297, during a stop on one of his journeys. Prince George Street is named after the consort of Queen Anne, Prince George of Denmark. Their union was not a fruitful one as out of eighteen pregnancies all but five failed to reach full-term and only one son, William, Duke of Gloucester, survived any length of time. Even he died at the age of eleven after contracting smallpox.

Lymbourne Road is named after the Lymbourne Stream, itself an Old English name meaning 'the brook in the field'. Wade Court Road is the sole reminder of the ancient manor of Wade, a name referring to this as wetland, and which was held by Juliana de Wade and which passed to the Earl of Arundel. Waterloo Road was developed shortly after the famous battle in 1815.

Manor Close was, predictably, cut on the site of the old manor house. Market Parade occupies part of what was formerly Market Street. James Adam Napier Martin, JP, gave his name to Martin Street. The Norris family had been rectors of Warblington for 140 years, fully meriting the naming of Norris Gardens. Warblington House was the home of the Marquess of Tavistock, hence Tavistock Gardens and the Duke of Bedford is commemorated in Bedford Close. Admiral Luard and his family lived at Warblington Lodge and gave their name to Luard Court.

Sir George Thomas Staunton (1781-1859), lord of the manor, who resided at Leigh Park gave his name to Staunton Road and also funded the new road which allowed him easier travel from his home here to Portsmouth, which was given the then popular (if unimaginative) name of New Road. Stone Square was named after W.H. Stone, who served as MP in 1859 and who gave this land to the people of Havant as a part of the Stone Allotment Trust.

Trosnant House, a Celtic name meaning 'by the brook', was built by George Thomas, chairman of the School Board in 1896, and the name was transferred to Trosnant Road. Union Road was cut where the Union Workhouse formerly stood in West Street and which was demolished in 1947. Whicher's Gate is named after George Whicher, a butcher who grazed his animals in the area known as Havant Thicket.

James Road is named in honour of Admiral Sir William Milbourne James (1881-1973), Commander-in-Chief at Portsmouth during the Second World War. A life in the Royal Navy between 1901 to 1944, including Naval Intelligence during both World Wars, was followed by a brief period as Member of Parliament for Portsmouth, after which he retired from public life and turned to writing. However, he probably regretted being the grandson of the artist Millais, who painted several images of the young William, including one which featured him gazing spellbound at a bubble he had just blown. Entitled *Bubbles*, it later became famous when used as the image in an advertisement for Pears Soap. The admiral never lost the soubriquet 'Bubbles', much to his annoyance.

Pook Lane is recorded as the home of one Roger Pook, a landowner who was certainly here by the fourteenth century, and a road which took the family name. Locally it has always been referred to as Spook Lane, a name clearly intended as a warning of it being haunted. No reports of any ghostly activity is recorded and it has been suggested this tale was invented to deter any from visiting there at night, thus reducing the chances of discovering the smugglers taking this route from Langstone Harbour. However, the 'spook' idea would seem to be a classic example of creative etymology i.e. the story was created to fit the name.

Public houses here include the advertisement in the Malt & Hops, the tradesmen in the Parchment Makers, the sea with Perseverance, and a nineteenth-century troopship. The Cobden Arms was named after Richard Cobden, who was a major player in the repeal of the Corn Laws in the nineteenth century, and the Robin Hood was a meeting place (also known as courts or lodges) for the Ancient Order of Foresters.

HAWKLEY

From Old English *hafoc-leah*, and found as Hauecle in a document from 1207, this is 'the woodland clearing frequented by hawks'.

HAWLEY

Two documents from the middle of the thirteenth century offer this name as Hallee and Halely, which are quite different and an indication of how difficult deconstructing place names can be. As evidenced by Domesday, common words are quickly understood and recognised when the scribes read them in other documents. Thus a standard spelling of the name soon develops, although this can differ depending upon who has read what and where! Furthermore there is no reason to believe they could remember how to spell a word any more than we can today, and it was not until the eighteenth century that the first dictionary appeared, courtesy of Dr Samuel Johnson. When it came to proper names there were no rules and phonetic spelling was the only criteria. This depends upon the ear of the listener, the understanding of the scribe, and the accent of the speaker. Even when this only involves three individuals it can produce a major corruption when it is written down. What became a problem for defining place names has exactly the same principal as the timeless entertainment called Chinese Whispers.

Here Old English *heall-leah* speaks of 'the woodland clearing near a hall, a large house' or it could point to *healh-leah* 'the woodland clearing at the nook or corner of land'.

HAYLING ISLAND

The island is listed as Heglingaigae in 956 and Halingei in 1086, which has a meaning of 'island of the family or followers of a man called Haegel'. The three elements here are the Saxon personal name with Old English *inga* 'family, followers' and *eg* 'island' – and thus what the Saxons conveyed in one word has become two words today. This is a comparatively modern development and was probably only seen following the founding of the following names.

Eastoke is a district name which has also been seen as East Stoke, itself the Old English meaning which translates to either 'the eastern outlying settlement' or 'the eastern settlement of or by the tree stumps'. Sinah Common and Sinah Lane have a common origin, found as Seynor in 1440 and ultimately from Old English for 'the bank of land at the marsh'.

Life near the sea has influenced the name of the pubs here, such as the Ferryboat Inn, Kittiwake and the Olive Leaf, which is part of the arms of the Shipwright's Company. Hayling Billy takes its name from the locomotive which stands in the forecourt. This once travelled the line from Havant until its closure in the 1960s. The Yew Tree Inn takes its name from a prominent tree, and the Rose in June is an allusion to the heraldic emblem associated with the royal house of Tudor.

HAYLING (NORTH & SOUTH)

Both these places come from the same source as the previous name and mean 'the family or followers of Haegel'. The larger, and presumably older, settlement is the southern one and was not known as such until the secondary northern settlement appeared.

Here we find minor place names which have their own histories to reveal. Mengham is a name seen since the thirteenth century, appearing as Mongeham, Meyngham and in the modern form as early as 1352. This is thought to speak of 'the farmstead associated with the family or followers of Maeg'.

HAZELEY

Listed as Heishulla in 1167, this is from Old English *haes-hyll* and describes the '(place at) the brushwood hill'.

The local Shoulder of Mutton public house is likely to have taken its name from a name in the landscape, referring to a lump in the ground. However, it might refer to a delicacy of the days of the coaching inns when a shoulder of mutton would have been served with a cucumber sauce.

HEADBORNE WORTHY

Found as Hydeburne Worthy in 1270, the basic name comes from Old English *worthig* meaning 'enclosure'. The addition is to differentiate between this, Kings Worthy and Martyr Worthy, and is derived from the stream name which itself can be seen as 'the stream by the hides of land' from *hid-burna*.

HEADLEY

A fairly common place name, found throughout England and which invariably comes from Old English *haeth-leah* and describes 'the woodland clearing where heather grows'. It is recorded as Hallege in 1086 and Hetlinga in 1190.

The name of a local old manor is still seen in the name of the farm and that of the road serving it, Broxhead Farm Road. This is a name that comes from *brocces-heafod* or 'the hill of the badger'. Note that what is considered the traditional personal name for a badger is in fact the word used in Old English, so the difference in spelling can be ignored.

Minor names here include Lindford, which is possibly 'the ford of the lime tree place'.

HECKFIELD

Recorded as Hechfeld in 1207 this name comes from Old English, but without other early forms for comparison it is difficult to see if this is *hecg-feld* or *hecc-feld*. The former would give 'the open land by a hedge', while the latter tells of 'the open land near a hatch gate'. Visually there would be little difference between the two. The hedge would have been created by removing unwanted vegetation, not planted as today, while the hatch gate is an access point within the hedge. This may seem a trivial distinction but is important. As stated, the hedge simply existed as being that which was not cleared when the man-made field was created, and was a pre-existing

boundary. This also suggests that those who cleared the land were the first to settle here. However, if they settled by an access point to the cleared land, it suggests this settlement grew alongside one already established and could well have been a secondary hamlet or village. In the second example the secondary settlement became dominant as far as names are concerned, and the original place name is either lost or now considered a minor area.

Minor names include Holdshott Farm, the name of an old hundred which referred to the '(place at) the nook of land in a hollow'.

HEDGE END

Unlike the previous name the derivation of this name is self-explanatory. This is largely because it is so recent, the first record coming from 1759 when it appeared as Cutt Hedge End – the difference seen as meaning 'clipped', just as hedges are today. The name also shows that it cannot have occurred before the estate with the clipped hedge alongside.

From the Old English *sceamolhyrst* and recorded as Scamelherst in 1174 and Samelhurst in 1212, the region of Shamblehurst to the north-east has a name meaning literally 'bench wood'. However, the understanding of this definition depends upon whether this is 'the wood for benches was obtained', or 'wood on a bench' that is to say where lumber was stored. The former is more likely with the woodland element *hyrst*, which always refers to a 'wooded hill'. Wildern is from the Middle English *wilderne* and refers to 'the wilderness or waste'.

Local pubs include the Barleycorn, a reference to the cereal crop used to make liquors.

HERRIARD

Records of Henerd in 1086 and Herierda in 1160 have an uncertain meaning as this is a very unusual etymology, particularly in Hampshire. This means it would have been misunderstood very easily and evolution has clouded the meaning. The favoured origin is Old English *here-geard*, which means 'army quarters' logically referring of that of the foe and hence most likely Vikings. It is certain that Viking forces would have established a foothold at many points around the coastline not associated with their settlements and, in some places, could have remained *in situ* for a significant period, leading to the development of this name. As long as the Vikings kept to themselves and posed no threat to the resident Saxon population, it is likely that they would be left alone. Alternatively this may be an older British or Celtic name, derived from *hyr-garth* and speaking of 'the long ridge'. This fits the local topography but such names rarely persist for smaller hills and landscape features as exist here.

Here is a minor place name from Old English *bagga-mere* or 'the badger pool'. It is recorded as Baggemere in 1245 and Baghemeresfeld in 1273. The local pub is the Peacock Farm, which is named after a family who once owned the farm on this site and provides the signwriter with a great opportunity to show off their skills.

HIGHCLERE

Listed as Clere in Domesday and Alta Clere in 1270, this name for a part of the county which stands higher than the surrounding region comes from Celtic river name referring to 'the bright stream'. The thirteenth-century record is clearly a written addition for it is Latin *alta* meaning 'high'. At that time Latin would have been a language only used in religious ceremonies and written records.

HILL HEAD

A recent name and self-explanatory.

HINTON AMPNER

Another common English place name and one with two different origins which are often difficult to distinguish between. Records of Heantun in 1045, Hentune in 1086 and Hinton Amer in the thirteenth century show this particular example to be 'the high farmstead' where high should be understood as 'chief'. The addition is from the Old French *aumoner* meaning 'almoner' and referring to its early possession by St Swithun's Priory at Winchester.

HOLBURY

Recorded as Holeberi in 1187 this name comes from Old English *hol-burh* and speaks of 'the stronghold in a hollow'.

HOLT

A common place name, often appearing as an element of a name, and is recorded in the modern form as early as 1167. That it has not evolved since Saxon times is hardly surprising for it comes from Old English *holt* meaning 'woodland thicket'.

HOLYBOURNE

Recorded in Domesday as Haliburne, this name comes from Old English *halig-burna*, meaning the '(place at) the holy stream'.

HOOK

This place near Basingstoke is listed as La Hok in 1238. Coming from Old English *hoc* the name refers to 'the hook of land', and to a place on a bend in a river or a hook or arc of higher ground.

Local pubs include the Hatchgate, marking the point where a gate of half the normal height allowed deer to escape but still penned in livestock. The Crooked Billet literally means 'the bent stick' which would have been what the original sign was hung on, so perhaps it was lost and the only 'sign' was what had once held it. The Jekyll and Hyde is named after the novel by Robert Louis Stevenson and was probably to show the place (or someone associated with it) had two sides to its personality, as did the character in the story.

HORDLE

Records of Herdel in 1086 and Hordhull in 1242 point to the Old English elements *hord-hyll*, which intriguingly have an origin in 'the hill where treasure was found'. These references to hoards are not as uncommon as one would think and, almost without exception, refer to the Anglo-Saxons uncovering Roman valuables. Obviously a Roman would have buried coins or precious metals in order to retrieve them at a later date and, as these places are rarely associated with Roman occupation, this perhaps means that they had been siphoning off valuables. Such nefarious acts are unrecorded, of course, and so we cannot guess who was responsible and why the cache was never recovered. From this we could assume it was a lower-ranking citizen, maybe a soldier, who was unable to return to the scene to recover his ill-gotten gains. This could have been for a multitude of reasons, or perhaps they were caught and executed for their crimes. It is also possible that at least some of these hoards were buried by their owners, perhaps to avoid them falling into the hands of robbers or even the taxman.

The name of Gordleton to the north-east, found as Gorlitun, Golreton and Gorlington in the thirteenth and fourteenth centuries. These names are comparatively recent and this Saxon 'farmstead' has never been understood. The pub here is the Three Bells, the number of bells in the peal of the local church at one time.

HORNDEAN

Recorded as Harmedene in 1199 this place name is certainly from Old English *hearma-denu*. The understanding of that term, however, is unclear. Normally given as being 'the valley of the dormouse', this would mean the tiny creature would have been plentiful here. Yet the dormouse is an introduced species, brought to this country by the Romans and prized as a food item. Being non-native they hibernate here for even longer than on the continent which, even in the warmest areas, can mean they actually spend more time hibernating than they are alert. This would hardly make the dormice particularly evident, indeed they are shy, secretive creatures and few people have seen one. Thus it seems the alternative is more likely, and that this is a personal name and 'Hearma's valley'.

HOUGHTON

Listed as Hohtun in 982 and Houston in 1086, this is a common place name usually found with a second distinctive element. With a name meaning 'the farmstead on a ridge or hill-spur', this is of Old English origin from *hoh-tun*.

HOUND GREEN

For once Domesday's record is perfect as Hune, which is from the Old English *hune* meaning '(place) where the hoarhound plant grows'. Known to science as *Marrubium Vulgare*, a tea made from this plant is still considered an effective decongestant and cure for the common cold. Perhaps this was a herbal remedy and was gathered here in Saxon Hampshire.

HURSLEY

Listed in 1171 as Hurselye, this name comes from Old English *hyrse-leah* and is probably 'the woodland clearing of the mares'.

Minor names here include Merdon Castle, built in 1138 by Henry de Blois. The name has proven difficult to define for the normal origins of *mere* 'pool' and *gemaere* 'boundary' simply do not apply here. It has been suggested as being 'the hill of the mares', which fits the forms but this is not recorded as being a stud for horses. Standon is from Old English *stan-denu* 'the stony valley'. One early resident was a Royalist, publicly declaring his allegiance in the name of the Kings Head public house.

HURSTBOURNE PRIORS

Listed as Hysseburnan in 880 and Essenorne in 1086 the name refers to the stream here, itself named from the Old English *hysse-burna* and referring to 'the stream with winding water plants'. This probably refers to canary grass, which would have been gathered and dried as winter fodder for sheep. The addition comes from it being a possession of Winchester Priory.

HURSTBOURNE TARRANT

As with the previous name, this is the stream name meaning 'the stream with the winding plants'. The addition refers to its possession by Tarrant Abbey. The stream in question is now marked on modern maps as being the Bourne Rivulet, a less imaginative name from Old English *burna* and has a self-explanatory modern addition.

The pub here is the George & Dragon, a statement of national pride featuring the patron saint of England and his famous deed.

HYTHE

Listed as La Huthe in 1248, this name comes from Old English *hyth* and refers to 'the landing place or harbour'.

Pubs here include the Lord Nelson (England's greatest hero has more pubs named after him than any other individual); Gleneagles, named by a golfing enthusiast; and Ebeneezers, which can only refer to the fictional miser Ebeneezer Scrooge.

CHAPTER 9

I

IBSLEY

Records of this name include Tibeslei in 1086 and Ibeslehe in the fifteenth century. This has been seen as 'the woodland clearing of a man called Tibbi or Ibba' (or even Tibba or Ibbi). Any loss of the initial 'T' is not unusual.

IBTHORPE

Recorded as Ebbedrope in 1236 and Ybethrop in 1269, this name comes from Old English *throp* with a Saxon personal name and speaks of 'Ibba's outlying farmstead'. The question remains as to which was the original settlement, however this will probably remain unanswered.

IBWORTH

Listed in 1233 as Hibbewrth and as Ibbewrth in 1245, this name comes from the Old English term for 'Ibba's enclosure'.

IDSWORTH

A name which is similar to that of Ibworth and has a similar meaning in 'Iddi's enclosure'. The name is found as Hiddeswrthe in 1170, Iddesworthe in 1200 and Idesworth in 1204.

One minor place name here is Welssworth, which may be 'Wealh's enclosure' but could be a late reference to 'the Welshman's enclosure'.

INHURST

Found as Hynehurst in 1236 and as Inehurst in 1256, this name comes from Old English and means 'Ine's wooded hill'.

ISINGTON

Either this is 'Esa's farmstead' or 'Isa's farmstead'. The early forms of Esinton in 1269 and Isynton in 1272 are not diverse or early enough for us to determine the personal name.

ITCHEN, RIVER

A river name which has never been understood. However, we can be certain that this is of pre-Celtic origins.

ITCHEN ABBAS

Recorded as Icene in 1086 and Ichene Monialium in 1167, the basic name comes from an ancient pre-Celtic river name. However, the Itchen has never been understood and without earlier records will probably remain so. The addition is from the Latin *abbatissa* meaning 'abbess' and alludes to its possession by the Abbey of St Mary at Winchester.

The Trout Inn reminds us that the Itchen has long been an excellent trout stream.

ITCHEN STOKE

Recorded as Stoche in 1086 and Ichenstoke in 1185, this second name refers to the unknown origins of the River Itchen, as discussed in the previous entry. We also find Old English *stoc*, here referring to a secondary settlement.

To the north is the almost entirely abandoned medieval village of Abbotstone. This name tells us it was 'the abbot's farm' and was held by Romsey Abbey before the Norman Conquest. Here the possessive 's' has become associated with the suffix *tun* and thereafter confused with 'stone', when the name should have evolved to Abbotston.

CHAPTER 10

K

KEMPSHOTT

Now almost indistinguishable from neighbouring Basingstoke, Kempshott began life as an independent settlement. Listed as Campessete in 1086, Kembeschete in 1269, Kempeschotte in 1280, and Kembeshute in 1346, this name comes from Old English *cempan-sceate* or 'the corner of land of the warrior'. However, it is possible this first element has been misunderstood and thus accidentally corrupted from the original *cenep* which, quite literally, means 'moustache' but is used more often to describe the appearance of a plant or its flower.

KEYHAVEN

Records of this name are limited to Kihavene around 1170. This comes from the Old English *cu-haefen* and informs us this was 'the harbour where cows are shipped'. Such names are a delight for the author, for it is one of those which produce an image just by defining a name. Wooden ships, docked alongside a stone and wooden quayside, with the drover encouraging his charges into the boat. One can only wonder where the cattle were heading.

The local pub is the Gun, a name which comes from a most unexpected source. This name points to a device in the coats of arms of Edward VI, Mary I and Elizabeth I.

KILMESTON

From a Saxon personal name suffixed by Old English *tun*, the name of Kilmeston is derived from 'Cenhelm's farmstead'. The name is found as Chelmestune in Domesday, with an earlier record as Cenelemestune in 961.

KIMPTON

This 'farmstead associated with a man called Cyma' has a Saxon place name with the Old English elements *ing-tun*. The oldest surviving record is as Chementune in Domesday.

Minor names here include a number of examples of the name Shoddesden, a place name recorded in Domesday as Sotesdene, in 1265 as Schottesdene, and in 1269 as Shottesden. This is undoubtedly 'Sceott's valley' and used as a personal name rather than 'the valley of the Scot or Irishman'.

KINGSCLERE

The earliest surviving record is as Kyngeclera in the twelfth century, but the place name certainly existed before this. The original Celtic name refers to 'the bright stream', with the addition Old English *cyning* or 'king' showing to be a royal manor.

Local names include Knowl, recorded as a separate settlement in Domesday as Chenol. This is from Old English *cnoll* and describes the terrain in 'the mound or rounded hill'. A crossing over a small tributary gave its name to Sandford, of obvious derivation and recorded as Santforde in 1240 and Sanford in 1248. Tidgrove is a name recorded in 1176 as Titegrave and refers to this being 'Tita's grove', a managed region of woodland.

KINGS ENHAM

A name seen in 1379 as Enham regis, showing it was a royal estate. The basic name comes from Old English *ean-ham* 'the lamb estate', that is, one where sheep are reared.

KINGS SOMBOURNE

Found as Swinburnan in 909, Sunburne in 1086 and Sumburna in 1155, this name undoubtedly refers to 'the pig stream' which was a royal manor even before the arrival of the Normans in 1066. The stream in question is a tributary of the River Test.

Minor names here include Upper and Lower Eldon, which together once formed a single independent parish. With the church at Upper Eldon it may be safe to assume this was the original settlement, in which case this is 'Ella's hill' from Old English *dun*. If, however, the assumption is incorrect and Lower Eldon was the original then this would be Old English *denu* and 'Ella's valley'. It is impossible to say which was the original place name, although undoubtedly the second name was influenced by the former.

KINGSLEY

Here is the same element seen in the previous name. This is Old English *cyning-leah* or 'the royal manor in the woodland clearing'. It is recorded as Kyngesly in 1220.

KINGSTON

For the third time the element *cyning* is seen, here with the addition of *tun*. This Old English place name describes 'the king's farmstead', and is listed as Kingeston in 1194.

KINGSWORTHY

Records of this name include Worthige in 825, Ordie in 1086, and Chinges Ordia in 1157. This name refers to the *worthig*, an Old English name for 'the enclosure' and one which was in the possession of the Crown.

The King Charles public house takes the name of King Charles I, beheaded in 1649, while the Cart and Horse is a reminder of the days when publicans acted as agents for the transport of goods.

CHAPTER 11

L

LANGRISH

A name recorded as Langershe in 1236 and which comes from Old English *lang-rysce*. This was the '(place at) the long rush bed', and a name which is easy to see lying behind a line of reeds and thus the ideal place name, allowing an instant image of Saxon life here.

The minor place name of Stroud is derived from Old English *strod* and refers to this being 'at the brushwood covered marshland'.

LANGSTONE

First listed in 1289 as Langeston, this place name is derived from the Old English *lang-stan* and speaks of the '(place at) the long stone'.

The Ship Inn is a fitting pub name for a place so close to the sea.

LASHAM

Domesday records this name as Esseham, while a century later the name is exactly as it is today. There are two schools of thought here, that either this is Old English *laessa-ham* and telling us this is 'the smaller homestead', or perhaps the first element is a nickname for someone of small stature.

LAVERSTOKE

Recorded as Lavrochestoche in 1086 in Domesday. This comes from Old English *lawerce-stoc* and tells us it was 'the outlying farmstead frequented by larks'.

The Langrish Millenium village noticeboard.

LECKFORD

This name is derived from the Old English *leaht-ford* and describes 'the ford at the channel'. The place name is recorded in 947 as Leahtforda and as Lechtford in Domesday.

LEE

A more common place name than would be apparent, for normally this is a minor place name found within a parish or district. It comes from the Old English element *leah*, meaning 'woodland clearing' and is usually found as a suffix. This would tend to suggest an early Saxon name, yet the earliest record we have dates from 1236 as Ly, which indicates that there was probably a first element which is now lost.

LEE ON THE SOLENT

As with the previous name this is simply 'the woodland clearing' and is recorded as Lie in 1212. The addition, for obvious reasons, refers to that famous arm of the sea between the mainland and the Isle of Wight which is discussed under its own entry.

Other names which show the close proximity of the sea are the Inn by the Sea and the Old Ship. The Bun Penny is an unusual name, it refers to the penny coin issued from 1860 to 1895 which featured the image of Queen Victoria wearing her hair in a bun.

The Links public house, Liphook.

LINKENHOLT

Domesday records this name as Linchehou in 1086 and as Lynkeholte around 1145. This is an Old English place name from *hlincen-holt* and referring to 'the wood by the banks or ledges'.

There is an earthwork here named Grims Ditch, an earthwork attributed to Woden who is sometimes referred to as Grim. The name is recorded as Grimesdich in 1272.

LINWOOD

A name recorded in 1200 as Lindwude has changed little over the intervening centuries. Here the origin is in Old English *lind-wudu* and telling us this was then 'the lime tree wood'.

LIPHOOK

The earliest record of this name comes from 1364 as Leophok. This is from the Saxon or Old English tongue, where *hliep-hoc* speaks of 'the angle of land by the deer leap or steep slope'.

The Links public house is close to the golf course; the Black Fox Inn is an element from a coat of arms, as is the Green Dragon which comes from the arms of the Earls of Pembroke.

The Whistle Stop public house, Liss.

LISS

An unusual place name which has come from the Celtic or British languages. While this is not unheard of, such etymologies are almost exclusively restricted to topographical features such as hills or water features. Here the name is recorded as Lis in Domesday, the perfect Celtic form for *lis* is a word used to describe the 'court, or chief house in a district'. Whatever significance this court had it must have held office for some considerable time in order for the name to have endured for over seven centuries after the arrival of the Saxons and with them the beginnings of English.

To the south-east the name Hill Brow accurately describes its setting on a long well-defined ridge.

The Flying Bull is said to have been an old coaching inn on the route from London to Portsmouth, supposedly taking its name from the names of two coaches which called here called the Fly and the Bull. In later years this town was associated with the railways, as seen by the names of the Whistle Stop and the Crossing Gate.

LITCHFIELD

Unlike the Staffordshire city this place name has a 't', although it is the most common misspelling of the Midlands name. This is not the only difference, for the origins and thus the meaning are quite different. Here the Old English *hlif-scelf* has produced the '(place at) the shelf of land with a shelter', and is recorded as Livesselle in 1086 and Lieueselva in 1168.

LITTLE ANN

The basic name here is derived from the river, an old Celtic river name probably meaning 'at the ash trees'. This place name is first seen in 1540 as Anne Parva, with the Latin addition *parva* meaning 'small'.

LITTLE SOMBORNE

A name not seen before 1204 when it is found as Parva Sunburn, a name distinguishing it from King's Somborne but having identical origins. Standing alongside the tributary of the River Test which gave it a name of 'the pig stream', the addition marks it as being smaller than the royal manor to the south-west.

Locally we find the name of Woolbury Ring, an Iron Age earthwork of twenty acres which is recorded as Welnabyrig in 947, Wolebury in 1553, Wulbury Hill in 1593 and Worlbury Hill in 1817. The origin of the name is unclear but may refer to 'the fort of the riches', a name which would fit with the treasures often found in barrows, although there are no documented finds here.

LITTLETON

It would seem that this is 'the little farmstead' from Old English *lytel-tun*. It is recorded as Litheltone in 1285 and was certainly named in comparison to a larger settlement nearby, although this is speculative.

LOCKERLEY

Domesday's record of Locherlega points to this being from Old English *locere-leah* or 'the woodland clearing of the keeper or shepherd'. This is an unusual development for normally we would expect the sheep to be referred to and not the shepherd, which suggests this may not have been where the animals were grazed or even housed. Indeed this may be referring to a gamekeeper, or an early approximation of such, for the role as we know it did not exist during Saxon times. Perhaps we should see this as someone who was responsible for keeping an eye on this part of the New Forest, even though it lies north of that National Park today.

LODDON (RIVER)

A Celtic river name which has an unknown element from those early British languages, but we may find a later equivalent from the Germanic tongues of the Indo-European group of languages. If we can assume such basic words are similar in various languages, and this is indeed the case with others, then this is 'the muddy stream'.

LONGMOOR

No surprises here – this name is first found in 1298 as Longemore and, as expected, refers to 'the long moor'. There is also Longmoor Camp army base nearby, which took its name from the village.

LONGPARISH

A name which was not seen before 1389, when it was recorded as Langeparisshe. The name is self-explanatory but it is worth noting that this was not the original name of the place. It was earlier called Middleton which, recorded as Middeltune in 1086, came from Old English *middel-tun* and, once again, has the obvious meaning of 'the middle farmstead'.

Locally we find the name of East Aston, where the basic name means 'the eastern farmstead' the addition of 'East' refers to its position relative to Middleton.

LONGSTOCK

Yet another 'long' place name, although that addition was not seen until 1233 in Langesto. Earlier, in Domesday, the name was simply Stoches, and Stoce as in a document of 982. This is from Old English *stoc* or 'outlying farmstead' with the later addition of the Saxon *lang* referring to its shape.

LONG SUTTON

Found in a record from 979 as Sudtun, as Sudtone in 1086 and as Lang Sutton in 1234. Here, the original 'southern farmstead' took the addition 'long' to distinguish it from Bishop's Sutton.

A local name of Well comes from Old English *wielle* and refers to the 'spring' which feeds the pond here.

LOWER PENNINGTON

The only record of note referring to this place comes from the twelfth century as Penyton. This probably comes from Old English *pening-tun* and describes 'the farmstead paying a penny rent'.

LYDE (RIVER)

A tributary of the Loddon, this is a common Old English river name from *hlud* or *hlyde* meaning, quite simply, 'loud' or 'torrent' respectively. Either can be recognised as referring to the same thing, a fast-flowing and noisy stream.

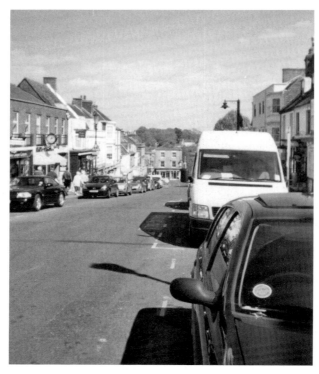

Lymington High Street.

LYMINGTON

Records of this name include Lentune in 1086 and Limington in 1186, which probably speak of 'the farmstead on a river called Limen'. Here the Old English *tun* follows a lost Celtic river name which likely referred to the 'elm river' or even 'marshy river'.

A suburb of Lymington has a name recorded as Penyton and Penington in the twelfth and thirteenth centuries respectively. Pennington reveals itself to be 'the farm on which a penny rent was paid'.

Street names are taken from a refreshingly wide variety of sources. An example is Mosbach Place, a reference to the German town twinned with Lymington. Lymington is also twinned with Vitre in France, Almansa in Spain, Messina in Italy, and Odessa in the Ukraine, giving other potential names. Pound Road is more ancient, a remnant from the days when stray animals were penned here.

Ashley Lane led to the Ashley Hill Estate, owned by John Walter in 1809. Rashley Mews remembers Rashleys, the builders founded by Tom Rashley who came to Lymington in around 1860. Victoria Place was cut during the early years of the reign of Queen Victoria. Stanford Road virtually has a history all of its own, for although it was named after the Stanford Building Works the site had been home to a stud farm in the 1860s, became South Coast Garages in 1900, and afterwards was the site of a cement merchants. Howlett Close is named after the owner of the Wellworthy Factory, John

The Church of St Michael & All Angels, Lynhurst.

Howlett. Under his ownership, the original bicycle repair business was tranformed into a company which hammered out countless thousands of piston rings.

Several maritime references are found in the pubs around Lymington, the Wheel Inn is named from the wheel which turned a boat's rudder; the Bosuns Chair the device used to winch men from a wreck to safety; the Mayflower was the vessel which took the first settlers to the New World; and the Fleur de Lys is most often used to symbolise France.

LYNDHURST

Found in Domesday as Linhest, this name comes from Old English *lind-hyrst* and speaks of the '(place at) the wooded hill growing with lime trees'.

The minor name of Bank is an excellent description of a ridge between the streams here.

Allum Green, the site of a bombing raid by the Luftwaffe in September 1940 resulting in the deaths of four British RAOC soldiers, is a name which is recorded in Domesday as Alwinetune. As a place name it is thought to come from the Old English meaning 'the farmstead of a woman calld Aelfwynn'. Any forms or suggestions of this being a British river name and related to Alum Chine and Alum Bay at Bournemouth and the Isle of Wight respectively are solely due to the close proximity of these places. Foxlease is a corrupted Old English *cocc-leah* or 'the woodland clearing where woodcock were trapped'. Gritnam is given as a separate manor in Domesday, the name referring to the 'homestead at the gravelly place'.

The Mailmans Arms is a name which reminds us that coaches and coaching inns were vital elements in the early postal service until superceded by the railways. The Crown and Stirrup is a unique reference to the royal hunting forest in the nearby New Forest.

CHAPTER 12

M

MALSHANGER

Recorded as Mailleshangre in 1390 and Maleshanger nine years later, this name features an uncertain surname with Old English *hangra* or 'the sloping or overhanging wood'. Three centuries earlier the place was recorded in Domesday as Gerlei, seen as Gerdelai in 1272, and describing 'the wood where spars were obtained' – that is where the woodland was managed, trees pollarded to produce poles or spars used in building fences, roofing, etc.

MAPLEDURWELL

A name recorded as Mapledrewell in 1086 and which comes from Old English *mapuldor-wells*. This was the '(place at) the spring or stream where maple trees grow'.

Where the river fills a depression to form a pond is seen as Enedewella and Anedewelle in the eleventh and twelfth centuries. This comes from Old English *eneda-wella* or 'the duck stream', a quite common place name is Saxon times.

Here the local pub is the Gamekeepers, a name which shows the place has long been used by those who protected the animals and birds on local estates.

MARCHWOOD

First listed in 1086 as Merceode, this place name is derived from the Old English *merece-wudu* and speaks of the 'wood where smallage (wild celery) grows'.

MARTIN

The earliest record of this name is as Mertone in 946. This comes from Old English *mere-tun* or *maere-tun*, meaning 'the farmstead near a boundary or by a pool'. Toyd Farm here takes its name from Old English for 'two hides' which was clearly related to geld or rent but in what context is uncertain.

MARTYR WORTHY

Found as Ordie in 1086 and as Wordia le Martre in 1243, the basic name here speaks of 'the enclosures' from the Old English *worthig* and usually seen as a suffix. The addition, to aid distinction from Kings Worthy, is derived from its possession by the le Martre family who were here by the thirteenth century.

MATTINGLEY

Found in Domesday as Matingelege, this is 'the woodland clearing of the family or followers of a man called Matta'. Here the Saxon personal name is followed by the Old English elements *inga-leah*.

Welcome to Meonstoke.

MEDSTEAD

Recorded as Medested in 1202, this form is rather late and isolated for us to be certain of its origins. There are seemingly only two possible beginnings, either *maed-stede* meaning 'the place of the meadow', or the first element is a Saxon personal name and refers to 'the place of a man called Mede'.

Minor names here include Soldridge, found as Solrigge in 1233 and describing 'the wallowing pond ridge'. This refers to a ridge creating a barrier and allowing water to accumulate and is distinct from the Dry Hill region to the north.

The Castle of Comfort public house takes a name designed to offer welcome to all prospective patrons.

MELCHET

In the past this has been considered part of Wiltshire. It was recorded as Michete in 1086, Milcet in 1236 and Mulset in 1244. This is thought to be a reference to an ancient name, something akin to very early Welsh *mel-ced* or 'the wood of or by the bare hill' and a region of ancient forest.

MEON (EAST and WEST)

These two places, less than two miles apart, are close enough to have had a common origin. Records of this name are found as Meone in 880, with Mene and Estmeone in 1086. The last two examples here show that West Meon is the original settlement. The name comes from the river, a Celtic river name thought to describe 'the swift one'.

Minor names include Oxenbourne, listed as Oxeburne in 1200, Oxeneburne in 1245 and Exeneburne in 1245, and telling of 'the stream of the oxen'. This is a headwater of the River Meon. Riplington, a name which crops up on more than one occasion, is found from the end of the twelfth century as Rippledon, Riplinton and Ripplinton, speaking of 'the farmstead of the long thicket'.

The Thomas Lord honours the man who retired to Hampshire after giving his name to Lord's Cricket Ground in London, the most significant of many contributions made to by the man to the game of cricket. The Izaak Walton is named after the author of *The Compleat Angler*. This seventeenth-century publication was the first definitive guide to the sport.

MEONSTOKE

A name recorded in Domesday as Menestoche, and one which is clearly related to the previous names. However, the suffix here is Old English *stoc*, meaning 'outlying settlement', and thus it is unclear if this is 'the outlying farmstead on the River Meon' or 'outlying farmstead reliant on (West) Meon'.

MICHELDEVER

Found as Mycendefr in 862 and Miceldevere in 1086, this is an unusual combination of two Celtic elements, although Domesday shows that by the eleventh century the first element had been confused with Old English *micel* meaning 'great' and which affected the later evolution of the place name.

Here the first element is thought to be a Celtic river name meaning 'boggy waters' and which is followed by a second Celtic river name *dubras* describing 'the waters'. It is unknown if this is two names describing the same thing from different aspects or two different names given to the same river.

Minor names here include that of Norsebury, which shows how easily place names can become adapted to produce a fanciful history where none exists. Here was a defensive feature or *burh* which was constructed on a *ness* or nose of land jutting out and making it easily defensible. Any idea of the Norsemen living here is solely because of the corrupted name. Southbrook is not exactly what it says it is but the 'land around the southerly brook'.

The Dove Inn is chosen to convey a message of peace; and the Half Moon & Spread Eagle has united two names, both of which are heraldic in origin.

MICHELMERSH

Recorded as Miclamersce in 985, this name comes from Old English *micel-mersc* and describes the '(place at) the large marsh'.

The local inn is the Bear & Ragged Staff, an heraldic image related to Richard Neville, Earl of Warwick (1428-71) and known as the king-maker. It has also been adopted as the emblem of Warwickshire. The connection with Michelmersh is unknown.

MILFORD ON SEA

This name is derived from the Old English *myln-ford* and describes 'the ford by a mill', clearly near the coast. It is recorded in 1086 as Melleford and the addition of 'on sea' is to be expected as this is a common place name.

To the west of Milford, on a spit of land stands the Tudor fort which gives this place its name. It seems unlikely that this is Old English *hyrst* or 'wooded prominence', but more likely a dialect term *hurst* or 'sandbank'. Efford is a local name which describes a 'ford passable at low ebb', that is, the crossing over then tidal Avon Water, which is no longer tidal because of the installation of a sluice gate.

The local is the Smugglers, although it would not have been known as such while the smugglers were active, for it does not pay to advertise where nefarious activities are concerned.

MILLBROOK

Found as Melebroce in 956 and, later, Domesday records this name as Melebroc. This is an Old English place name from *myln-broc* and describes 'the brook by a mill'.

To the west is the region known as Freemantle. This is probably a name transferred from northern France in Fromentel, literally 'the cold cloak' indicating an area of shade. Wimpson is listed as Wnemanneston in 1236 and Wynemanestun in 1269, and over the years the name has shortened more and more from the original 'Winemann's farmstead'.

Redbridge is named after the bridge which carries the A35 over the River Test. The name refers to 'the bridge by the reeds' and a glance at the waters below will reveal reeds growing here still. Prior to the bridge, which first appears as part of the name from the latter half of the tenth century, there was a ford and indeed the early forms of the name reflected this with Hreutford and Hreodford.

MILTON

A common place name in England which, as with all common names, has a very simple meaning. Here the place lies between Barton-on-Sea and Chewton Bunny and fully merits its name meaning 'the middle tun or farmstead'.

Locally is Fernhill Gate or 'the gap to the hill where ferns grow'.

MINSTEAD

A name recorded in 1086 as Mintestede is from the Old English or Saxon *minte-stede* and telling us this was 'the place where mint grows or is grown'.

North of the village is an old manor called Canterton as evidenced by the existence of Canterton Lane. That the lane runs away from Minstead towards Brook gives the impression that this belongs to the latter place, however historically it was a part of Minstead. From the etymologists viewpoint this is an interesting name for it comes from the Old English *cantwar-tun* and refers to 'the farmstead of the Kentish men'. Today there is a distinction between Kentish Men and Men of Kent, the former inhabit the county west of the River Medway, the latter the land to the east of that river. Each faction is rightly proud of their identity and will quickly and vociferously correct anyone who gets it wrong! However, there is no real difference between them, the distinction seems to come from the Norman Conquest when the Men of Kent are said, presumably by the Kentish Men, to have rolled over and submitted meekly to the invading Normans, while the Kentish Men stoutly defended their lands. Both groups had a unique ancestry, for they were not Saxons nor Angles, but Jutes from the region corresponding to Jutland, a region of modern Denmark. This settlement is one of a number of places in Hampshire whose names differentiate them from being Saxon in origin.

Stoney Cross virtually explains itself, for it stands on gravelly land at the point where two former Roman roads intersect. Shave Wood is a Middle English name from *schawe* and describes the 'strip of woodland on a field border'. Slufter's Inclosure is a much corrupted name referring to a bog, which was later drained via the stream which flows through the plantation.

MONKWOOD

A place which clearly took its name from ownership by the Church, probably the episcopal see of Winchester.

MONXTON

Found as Ana de Becco around 1270 and as Monkestone in the fifteenth century, the present name describes 'the estate held by the monks'. Earlier, the name reveals more, that the estate was on the River Ann and that the monks in question were from Bec Abbey.

Initially the Black Swan was only seen in heraldry, for until Australia was discovered with its indigenous population of black swans it was well-known that all swans in the world were white. That has given an added meaning to this pub name.

MORESTEAD

Meaning 'the place by a moor' and coming from Old English *mor-stede*, this place name is first seen in 1172 as Morstede.

MOTTISFONT

Domesday records this name as Mortesfunde and by 1167 this is seen as Motesfont. This is from Old English *mot-funta* and may mean either 'the spring near a river confluence' or 'the spring where meetings are held'.

The River Dun, a tributary of the Test, is not a river name but is an example of back-formation and is named from Dunbridge, a region south of Mottisfont whose name is derived from 'the bridge in the valley'.

CHAPTER 13

N

NETLEY

With records of Laetanlia in 953 and Latelei in 1086, this Old English place name comes from *laete-leah* which literally means 'left woodland clearing' understood as 'not farmed'. This could been seen to refer to land which had been left to lie fallow, yet if this was the case it would have been in this state for many years for the name to stick, thus it is probably better to say it was former farmland which had since been neglected.

However, this etymology does not explain why the name begins with 'N' and not 'L', something which does not occur before the fourteenth century. In fact there is no clear reason why this should be so, and thus it is thought to have been confused with the following name.

NETLEY MARSH

Unlike the previous name the etymology does explain this spelling, it coming from Old English *naet-leah* and refers to 'the wet woodland clearing'. The name is recorded as Natanleaga in the ninth century and Nutel in Domesday. Not until comparatively recent times has there been any addition, which is to distinguish it from the previous entry and once again emphasises just how wet this particular region has been.

Locally is the name of Hanger, a common minor place name and from the Old English *hangra* or 'wooded slope' and which generally appears as 'Hanging' and similar.

NEW FOREST

One of the loveliest regions of the entire country fully merits its designation as a National Park. The first record of it comes from Domesday as *Nova Foresta*, Latin for the 'new forest'. This had been recently created by William the Conqueror for the royal

The New Forest in spring.

The Fox at Newton.

hunt, so is one of the few place names of which we know exactly when it was created and by whom.

NEWNHAM

Found from the twelfth century as Neoham, Niweham, and Niwenham, all from Old English *niwan-ham* meaning 'the new homestead or estate'.

NEWTOWN

A 'new town' created by the Bishop of Winchester in the thirteenth century which became independent in later years.

NEWTON VALENCE

A name seen in Domesday as Newentone which has the predictable meaning 'the new tun or farmstead'. By 1250 this manor was held by William de Valencia, not the Spanish city but Valence in Normandy, although both were ultimately derived from the Latin personal name *Valentius* meaning 'strong, healthy'.

NORLEY WOOD

The name of this woodland speaks of 'the northern woodland clearing'. Hence the wood takes its name from the small settlement which was once found in a natural clearing and from this was applied to the woodland itself. The fact that this is the 'northerly' wood refers to it being to the north of South Baddesley.

NORTHAM

Domesday records this name exactly as the modern form. It is derived from Old English *north-hamm* and refers to the '(place at) the northern promontory'.

NORTH BADDESLEY

Records of this name are limited to Bedeslei in Domesday, which shows the name to mean 'the woodland clearing of a man called Baeddi'. The addition of North is to distinguish this place from another Baddesley, a small hamlet in Boldre.

NORTH CHARFORD

Records of this name are found as Cericesford and Cedreford in the ninth and eleventh centuries respectively. This undoubtedly is derived from the Old English for 'the ford associated with the chieftain Cerdic'. The addition, while an obvious one, is today superfluous for there is no other Charford near here.

NORTHINGTON

Found in a document dated 903 as Northametone, which shows the modern form to be incorrect. This name is from Old English *north-haeme-tun* and means 'the farmstead of the dwellers to the north' and would be expected to evolve as Northampton. This would probably refer to the settlements being north of Alresford or Winchester.

Minor names here include Totford, recorded as Totefort in 1167 and Toteford in 1201, and comes from 'Totta's ford'.

NORTH WALTHAM

Recorded in 909 as Waltham, in 1167 as Waltham, in 1208 as Norwaltham, and in 1291 as Waltham Parva, this name undoubtedly comes from Old English *weald-ham* 'the woodland estate'. The addition of 'North' distinguishes it from Bishop's Waltham.

Cuckoo Close was an early post-war development named by the builders.

NURSLING

Found as Nhutscelle around 800 and Notesselinge in 1086, these two forms show the evolution of the name. The earlier form means 'nutshell', while the later is Old English *hnutu-scell-ing* and means 'the nutshell place'. Undoubtedly this is a term used to describe a 'small home or settlement'.

NUTLEY

A name found in several places around England. It is recorded as Nutlie in 1212, Nutlega in 1219, Nutelegha in 1220 and Nottele in 1236. The name comes from 'the nut wood'. This would almost always refer to the hazelnut, which has historically been an important food source.

Just south of Nutley is the tiny hamlet of Axford. This name is found in 1272 as Ashore and in 1280 as Axore and is from Old English *aesc-ora* and describes 'the ash tree slope'.

Chapter 14

O

OAKHANGER

Found in 1086 in Domesday as Acangre, this Old English place name comes from *ac-hangra* and describes the 'wooded slope where oak trees grow'.

OAKLEY (EAST, WEST and NORTH)

To be correct there is no longer a West Oakley, as it is today either known as Oakley or Church Oakley. The three Oakleys are wildly scattered, but the additions to their names obviously refer to their position *vis-à-vis* each other. 'Oakley' is derived from 'the woodland clearing of the oak trees'.

ODIHAM

The present form is exactly how it appears in Domesday, the only early record of note. This name seems to be derived from Old English *wudig-ham* and tells of 'the wooded homestead'.

A local name is Murrell Green, seen as Morhale in 1167. The name is from Old English meaning 'the marshland nook of land' although whether the nook is marsh or dry land is open to discussion. Appearing as Rie in 1228 and la Rie in 1294, the name of Rye must surely refer to 'the raised land in the marsh', and yet there does not seem to be any really noticeable rise in the land here. Poland Farm does not show any connection to eastern Europe, it comes from Old English *pol-ing* and describes 'the place of the pool'.

Local pub names include the Waterwitch, a dialect term for the storm petrel. The Bell is an association with the church, while the monarchy are the inspiration behind the Crown and also the George.

The White Hart Hotel, Overton.

OSSEMSLEY

A name which is found in a number of places at the southern end of the New Forest. It comes from Old English and is recorded as Osemundeslee and Osmundesle in the twelfth and thirteenth centuries, a name meaning 'Osmund's woodland clearing'.

OTTERBOURNE

From Old English *oter-burna*, this name does indeed describe 'the stream frequented by otters'. The place name is recorded as Oterburn in 970 and Otreburne in 1086.

It seems inevitable that one local pub should be called the Otter while the Old Forge stands on or near the site of the village blacksmiths.

OVERTON

A common name and nearly always from, as here, Old English *uferra-tun*. Listed as Uferantum in 909 and Ovretune in 1086, this is 'the higher farmstead'.

The local pub is the Old House at Home, a common name conveying a message of it being home from home for customers.

Mile post at Southington.

OVINGTON

A name found in the tenth century as Ufinctune which points to this being 'the farmstead associated with a man called Ufa'.

OWER

A name found in the Domesday record as Hore, is one which comes from Old English *ora*, and telling us this was the '(place at) the bank or slope'.

OWSLEBURY

The sole record of note comes from 970 as Oselbyrig, which has two possible origins. This is either Old English *osle-burh* 'the stronghold frequented by blackbirds' or perhaps the first element is a personal name and 'Osla's stronghold'.

A record of this place from 1350 refers to the Croude family, a surname seen in the minor place name of Crowdhill with an obvious suffix.

Minor names here include Marwell Hall, itself taken from an earlier place name seen as Merewelle in 1182. This refers to 'the boundary stream' which is the tributary of the Itchen and forms the boundary between Owlesbury and Bishopstoke.

CHAPTER 15

P

PAMBER

Records of this name include Penberga in 1165, a name which comes from Old English *penn-beorg* and describes this place as 'the hill with a fold or enclosure'.

The local pub is the Pelican, not the bird but the ship in which Sir Francis Drake made his first round the world voyage completed in 1577, by which time the ship had been renamed the *Golden Hind*.

A simple but informative sign entering Petersfield. *An attractive pub at Petersfield.*

PENTON GRAFTON

As with the following name this is 'the farmstead paying a penny geld or rent', and is listed as Penitone in 1086, Penitone Grefteyn in the thirteenth century and Penytun Gresteyn in 1269. The addition here, to distinguish it from like names in Hampshire, refers to this manor being held by the Abbey of Grestein in French Department of Eure, itself named after the Eure River.

PENTON MEWSEY

Records of this name are found as Penitone in 1086, with the later form of Penitune Meysi in 1264. From the Old English *pening-tun*, this name tells us it was 'the farmstead paying a penny rent'. Here the de Meisy family, lords of the manor from the thirteenth century, gave their name to distinguish it from another place with the same meaning which has evolved slightly differently and is now known as Lower Pennington.

PETERSFIELD

The twelfth-century record of Peteresfeld probably shows this place name is telling us this was 'the settlement at the open land having its church dedicated to St Peter'. The suffix here is Old English *feld* or 'open land', an early form of field. An Old English *feld* was a man-made clearing, free from trees and undergrowth but, unlike the modern field, had no fence or hedge but just a border produced by the uncleared vegetation.

The street names and public houses of Petersfield reflect many aspects of the town's history. Anchor Street marks the site of the Anchor Inn; Dolphin Court remembers the Dolphin Hotel; the Green Dragon Inn gave its name to Dragon Street; and Swan Street comes from the Swan Inn, which would be more socially acceptable than one of the previous names of this street – since 1700 this has been known as Little London, London Lane, Rosemary Lane, Parsonage Lane, Back Lane, Spain's Lane and even Shite Lane, an estate agent's nightmare.

As with many towns' names those fields which once fed the community gave names to the streets which were developed to accomodate a growing population. Such names include Carrot Meadow which was still growing carrots in 1841; and Cow Legs Lane, where, previously, Cowlege was recorded as a close of three acres where cows would have been pastured.

Individuals who have given their name to local places include Thomas Antrobus who in 1622 left £100 to the poor single men and women of the parish. He is commemorated in the name of the Antrobus Almshouses that would have housed them. Clare Gardens and Gloucester Close recall the Clare family, who were Earls of Gloucester and Lords of Petersfield from 1220 to 1314. Goodyers remembers the former home of John Goodyear (1592-1664), the botanist who was steward of the manor of West Mapledurham. Hylton Road is named after William Jolliffe, 1st Lord Hylton (1800-76).

Kimber's Field takes its name from the family who once owned it. Merryfield remembers Thomas Merrifield, Alderman of Petersfield in 1511. Stafford Road is named

after the earls of Stafford who were lords of Petersfield from 1320 to 1521. While Garage Lane was indeed cut on the site of Urquhart's Garage, The derivation of Love Lane is not what it seems, but is named after Thomas Love, who bought Castle House, on this lane, in 1713.

However, the most interesting street names are those which have a story to tell, the names which give a window on a episode in the history of the place. For example we have already seen that Swan Street was, at least for a short period, known as Spain's Lane. This was not the only reference to the Iberian peninsular, for there is also The Spain and both are traditionally said to be where Spanish merchants would come to buy wool or cloth, but there is no known documented evidence to support this.

Another street name alluding to our European neighbours is Frenchman's Road. Yet this is no reference to *entente cordiale* for this was where French prisoners of war were quartered, possibly while working on the Portsmouth Road. However, as with the use of 'Spain', there is no written account to corroborate this claim and it may have been apocryphal. There is a record of French officers living in Petersfield between 1756 and 1763, leading a life of leisure on parole. This would certainly not have pleased the locals and thus may have been the basis for the idea of prisoners being used for hard labour.

A third street name to refer to the Continent is Noreuil Road. Easily seen as being French, it recalls the Housing Act of 1919 when the newly-built homes here were promised to ex-servicemen. The name is derived from the town of Noreuil near Arras in France, which stood on the Western Front during the First World War. During the post-war years Petersfield helped Noreuil with its rebuilding programme.

Lavant Street takes the name of a stream, not a stream name as such but a description of one which flows intermittently. This would not be entirely based upon the seasons, although rainfall would clearly be a factor, yet it is a regular feature of streams flowing through chalk country. The Mint is another street named after the countryside which existed here before the land was developed. A malthouse was sited here, where the local beds of peppermint supported a cordial industry.

Other trades are remembered by Reservoir Lane, which was known as Tilmer Lane in 1831 and a place where bricks and/or tiles were made. The road was renamed later in the nineteenth century when the reservoir was constructed. Lastly there are the names of Dyehouse Lane and Dick House which stands on it. While it is easy to see the street name as a reference to the tanners and dyers who worked here, the name of the house is less clear. Yet it refers to the same trade, for 'Dick' is an old word for an apron and one which would have been worn by both tanners and dyers.

PLAITFORD

Sometimes defining a place name can produce an image or snapshot of life in the community several hundred years ago. Plaitford is one such name, coming from Old English *pleget-ford* and describing 'the ford where sport or play takes place'. These games have been played here for some time, for the earliest record is found in Domesday, as Pletteford. It seems unlikely that any of these sports would be known to us, yet they would have been close to those played today, including running, throwing, and wrestling games.

POPHAM

Found in Domesday as Popeham, there is an earlier record in 903 identical to that found today. This is undoubtedly an Old English name, probably from *pop-ham* and describing 'the homestead in pebbly ground'.

PORTCHESTER

In 960 this name is recorded as Portceaster, which by 1086 and Domesday is Portcestre. Another Old English place name which comes from *port-ceaster* and describing 'the Roman stronghold by the harbour'.

Portchester's publicans seem to be particularly fond of seabirds, for there is both a Seagull and a Cormorant here.

PORTSDOWN

From the Old English combination of *port-dun*, and recorded as Portesdone in Domesday, this place name speaks of 'the harbour by the hill'.

PORTSEA

This name is found as early as 982, as Portesig. This comes from the Old English *port-eg* and tells us it was created at 'the harbour island'.

PORTSMOUTH

It seems this place name has endured for a long time and yet still is self-explanatory. Here, from Old English *port-mutha* and recorded as Portesmuthan in the late ninth century, is the '(place at) the mouth of the harbour'.

Farlington is a district which is found in the late twelfth century as Ferlingeton, with the modern form seen from the thirteenth century onwards. It has been suggested as being the 'the farm of those associated with Fearnleah', yet no such place is known. Perhaps this is an earlier place name on or near this site which is now lost beneath the modern concrete of Portsmouth or, less plausibly, is an association with Fareham. There is also a possible personal name for the first element here, something akin to Faerla.

In Farlington is the region known as Stakes but which was earlier recorded as Frundstapla, Frendestapele, and Freondestaple in the eleventh and twelfth centuries, with the modern form not seen until 1441 as simply Stake. These early forms seem to speak of this as 'the friend's post' or possibly 'friend' is here used as a personal name or a nickname. While the meaning is uncertain it may be that this was a regular meeting place of not friends but acquaintances, possibly businessmen who had a common interest or market. What is certain is the family of Stake, here in 1248, took their name from the place and not the reverse. Drayton is a common place name that most often comes from

Old English *draeg-tun*. Here is a 'portage', a place where goods were regularly dragged over a mudflat or up a slope.

Hilsea is a district whose name is probably a reference to the vegetation in 'holly island', where the 'island' is land in a marsh raised sufficiently high to remain dry when the surrounding land is marshy. Landport is referred to in a document of 1745 as Land Port Gate, showing it was an area outside the old town walls known as 'the landward place'.

Milton is recorded as Middelton in Porteseia in 1186, a name which refers to its location between Eastney and Fratton as 'the middle tun or farmstead'. Stamshaw is an odd place name whose derivation has posed some problems. It seems to come from Old English *stem-hoh* and 'the promontory of land marked by a post or posts', yet this first element is not actually known but is related to Old High German *stamn*.

The pubs of Portsmouth reflect its naval history with names such as the Admiral Drake, after Sir Francis Drake; the Golden Hind, after the ship in which Drake first circumnavigated the globe; the Shipwrights Arms; and the Navigators. The Mary Rose, brought back to the surface over four centuries after it sank in the Solent; Lady Hamilton, mistress of Horatio; the Victory and the Ship Anson, referring to a Royal Navy admiral and the vessel named after him. Next come the Invincible; Baffins Inn, after explorer William Baffin; the Jolly Taxpayer, a satirical name referring to the overly burdened worker; and the Isambard Kingdom Brunel, still regarded as an engineering giant in the modern era. Oliver Twist reminds us that Charles Dickens was born near here; the Battle of Minden, a 1759 engagement of the Seven Years' War fought against France and the Sir John Baker commemorates the Liberal MP for Portsmouth at the beginning of the twentieth century. The Mother Shipton was named after a woman who is said to have foretold the Gunpowder Plot, the death of Cardinal Wolsey and the dissolution of the monasteries, the invention of the steam locomotive, the telephone, aircraft and motor car, and who was born Ursula Southiel in 1488 in a cave near Knaresborough.

PORTSWOOD

Recorded as Porteswuda in 1045, this name comes from Old English *port-wudu* and describes 'the wood belonging to the market town'. This part of Southampton stands well above sea level and there can never have been a port here in the modern sense. In fact the original meaning of port was 'market'. It was sales on the quaysides when goods came from far-off lands which saw the word used in its modern sense.

Local pubs include the Mitre, named after the headgear of bishops and probably indicated that this was once land belonging to the Church; the Gordon Arms, after Major-General Charles George Gordon (1833-85) best remembered for his campaigns in China and northern Africa; and the complementary names of the Bent Brief and the Honest Lawyer, the latter seemingly too honest for the sign depicts him behind bars.

PRESTON CANDOVER

With a prefix to distinguish this place from nearby Brown Candover and meaning 'held by the priests', this name is recorded as Cendefer in 880, Candovre in 1086 and

A barrister one cannot trust is complemented by the nearby lawyer who may not be as honest as he is behind bars.

Prestecandevere around 1270. The basic name comes from the stream, a Celtic river name describing 'the pleasant waters'.

One local family is remembered in the name of the local pub, the Purefoy Arms.

PRIORS DEAN

The earliest surviving record is from 1198 as simply Dene, which comes from Old English *denu* or 'valley'. The modern addition is first seen in 1367, by which time the manor was held by Southwick Priory.

PRIVETT

This name undoubtedly comes from Old English *pryfet* which does indeed mean 'privet'. However, this should not be seen as anything like the neatly trimmed hedges of the modern world, in fact the only thing these have in common is that they are the same plant. This privet would have been a small copse, a marker for the settlement which took its name. The single early form of note comes from the ninth century as Pryfetes flodan, with the second element from Old English *flode* meaning 'channel, or gutter' and likely a natural drainage channel which soon vanished or was ignored as the place grew.

Regional names here include Basing Park, which takes its name from the de Basyng family who held this manor in the fourteenth century. Previously this place had been known as Langenhurst in 1307, describing it as 'the long wooded hill'.

PURBROOK

The thirteenth-century record of Pukebrok is likely to be misunderstood as something as unpleasant as the real origin. From Old English *pica-broc* this was 'the brook haunted by a goblin'. Sadly this snippet of folklore was never set down on paper and, while it most certainly would have troubled the local population at one time, is narrative now lost.

The Leopard public house probably takes its inspiration from the three leopard heads shown on the arms of the Weavers' Company.

CHAPTER 16

Q

QUARLEY

An odd development of this name, for it is first seen as Cornelea in 1167 and we would expect it to have evolved into something very similar today. We can be sure this comes from Old English *cweorn-leah* and speaks of 'the woodland clearing where mill-stones are obtained'.

QUIDHAMPTON

Domesday records this name as Quedementun, a place name which comes from Old English *cwead-ham-tun*. Here the problem is not what the name means but what message is being conveyed and, more importantly by whom. This may be a derogatory comment from a neighbour and describe 'the muddy home farm'. Alternatively if the place was fertile and highly productive it could be suggesting this was 'the home farm with good manure'.

CHAPTER 17

R

RAMSDEAN

A name recorded in the thirteenth century as Ramesdene, Rammesdene and Ramesdune, and one where the suffix is derived from Old English *denu*. The first element proves more difficult and the translation could equally be *ramm-denu* 'the valley of the rams', *hramse-denu* 'the valley where wild garlic grows' or *hraefn-denu* 'the valley of the ravens'. This last meaning could also be a possibly fourth definition, for the 'Raven' may also be a personal name or a nickname.

RAMSDELL

With records of Ramesdela in 1170 and Ramesdelle in 1248, this comes from Old English and describes 'the dell where wild garlic grows'.

REDENHAM

A name found in 901 as Readen hamme, in 1167 as Redenham and in 1256 as Radenham. It has the Old English suffix *hamm* and refers to the '(place at) red soils of the hemmed in land'.

REDRICE

An unusual name, both in the modern form and in its origins, which is recorded as Rederis in 1269 and le Rederys in 1306. This can only be Old English *readan hrise* or 'the red brushwood covered place', although just what plant was so abundant here as to give a reddish hue is unknown.

Kings Arms Lane, Ringwood.

RINGWOOD

Records of this name include Rimucwuda in 955 and Rincvede in 1086, and is a name which comes from Old English *rimuc-wudu* and describes this place as 'the wood on a boundary'.

Local names include Poulner, and it was listed in the fourteenth century as Polenore and Polenoure. The first element here seems to be an uncertain personal name, while the suffix is *ora* '(place at) the foot of the slope'. St Leonards and St Ives is a modern region and parish which takes the name of St Leonard's chapel in Beaulieu and combines it with a corruption of the Old English *ifett* or 'the ivy-covered copse', and not a saint at all.

Street names of Ringwood include Kings Arms Lane, predictably named after the public house and previously known as Rose and Crown Lane, a second pub which became a coffee shop when ownership changed to a Mrs Carter who was against the demon drink. However, it does make one wonder why a staunch and apparently vociferous teetotaller would ever even consider taking over a pub, perhaps so she could have had the name changed temporarily to Temperance Lane.

While every town has a High Street, historically the most important and not the most elevated, surely only Ringwood has a Mary Mitchell Close, a doctor from Christchurch who did great work in her later years working with the old folk of the town. Indeed Ringwood is refreshingly full of street names marking the achievements and contributions of former occupants, a delightful change and one which is well worth noting by the planning departments of other local authorties.

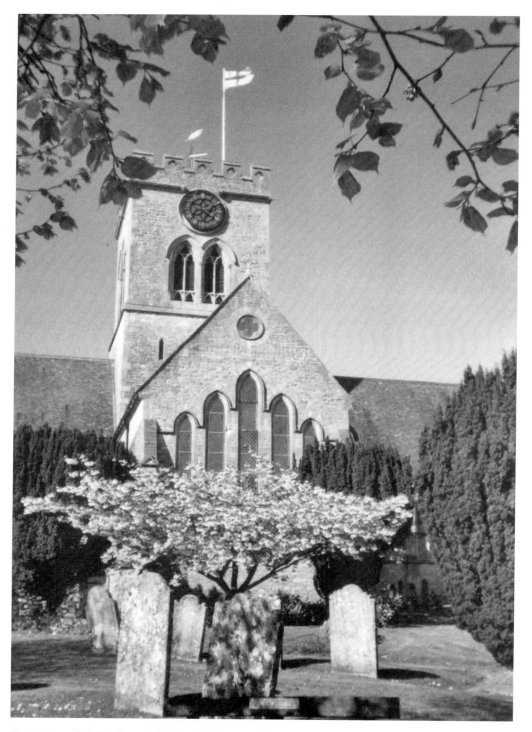

St Peter's and St Paul's parish church, Ringwood.

Kingsbury Lane marks the site of the wholesale grocery business owned by the Kingsbury family until 1949 when the last of the line, Arthur Henry Kingsbury, a fanatical supporter of local football and cricket, died and was the last person to be buried in the parish churchyard. The Market Place is still where customers are attracted by stalls that are pitched today and has been known as such since at least 1226. Amey Lane was where the saddlers and leather shop run by George Amey was. Strides Lane was named after the Strides family and earlier known as Carmatts Lane after the clockmaker who lived and worked here. Former jeweller and watchmaker's Deweys had their premises on what is now Deweys Lane.

Traditionally the name of Fridays Cross is said to commemorate the companion of Robinson Crusoe, who is thought to have come to Ringwood at around the age of forty. However, this is a fanciful etymology, and the real origin is from the cross erected here to mark where Christians would gather on Good Friday each year to mark the holiest day in the Christian calendar.

Duck Island Lane is a name of predictable origins, however on its way to the island it would have passed the home of a farmer who went by the interesting soubriquet of Pig Killer Johnson. Castleman Way occupies the site of a railway track built in 1847 by a Mr Castleman, while Lamb Lane is named after the Lamb Inn. In the 1920s and '30s George Seymour owned a garage in what is now Seymour Road.

Lyne's Lane takes the name of the family that owned Leybrook manor from the sixteenth century, one of the most affluent of the local families. However, one of the most deserving long-time residents remembered was Dorothy Charlotte Sibley, who lived out the last few months of her life in Bridgend, South Wales where she died on 25 January 1996, aged 102. She had lived the vast majority of those 102 years in Granny Sibley's Lane, which is today known simply as Granny's Lane.

RIPLEY

Domesday shows this as Riple. It is a common place name and describes 'the strip-shaped woodland clearing'.

ROCKBOURNE

Here Old English *hroc-burna* gives a meaning of 'the stream frequented by rooks', and was recorded as Rocheborne in 1086. Locally is the similar name of Rockstead, a separate manor in the thirteenth century and with a name derived from 'the rook's dry ground in the marsh'.

The local is the Rose and Thistle, named to mark the Act of Union between England and Scotland.

ROMSEY

Listings of this name are from 970 as Rummaesig and in 1086 where the Domesday record is identical to the modern form of this name. Undoubtedly this is an Old English

name and features a Saxon personal name followed by the element *eg* and describing 'dry ground in marsh of a man called Rum'.

Broadlands, the estate and former home belonging to Earl Mountbatten, is first seen recorded as Brodeland in 1541 and as Brodelandes in 1547, the name referring to 'the broad cultivated land'.

Cupernham was once an isolated hamlet but is now a district of Romsey. A record from 1248 as Cuperham is followed by Kiperneham 1272, Cupernam 1316 and Kippernam in 1586, which together point to its location between the River Test and a small tributary. This is one of the author's favourite kinds of place names for it produces an image enabling an artist to envisage life here in the Saxon era. This was 'the piece of land with the buildings where fish baskets were made' and is typical of the location of such settlements. Spursholt House takes its name from Old English *spearres-holt* or 'the managed woodland where pollarding produces spears, spars, rafters and beams'. It seems certain that these items were stocked here too.

The suburb of Halterworth has proven difficult to define, for there are at least two equally plausible definitions from an identical beginning. This is Old English *Heald-treow-worth* and either 'the enclosed land of tree shelter' or 'the enclosure of the tree slope, or leaning tree'. Pauncefoot is a manor found from 1206 as Pancevot and in 1487 as Paunesfotes Hill, which refers to the de Pauncefot family who were here from at least the thirteenth century. Interestingly this is a Norman French surname derived from a nickname, and not a particularly flattering one, referring to one of 'the arched belly'. Whitenap takes its name from 'the white harp', a name thought to have evolved from this branch of the Test formerly being tidal and enabling its waters to be evaporated in order to produce white salt, used for drying and preserving meat.

Streets of Romsey are named after history in general – the obvious example being Alma Road, named after the famous engagement which is generally held to be the first battle of the Crimean War. Fought in September 1854, a combination of French and British troops under General St Amaud and Lord Raglan defeated the Russian Army under General Menshikov. Over 9,000 individuals lost their life that day.

Latimer Street takes its name from a stream name of Lortemere meaning 'the slow moving stream'. Palmerston Street remembers that the former prime minister Lord Palmerston used to reside in Romsey. He lived at Broadlands and was affectionately known to the locals as 'Good Old Pam'.

Local pubs include the Cromwell Arms, recalling the attack on nearby Winchester; the Three Tuns, depicting the large barrels or casks which held the drink; Bishop Blaize, who was the patron saint of cloth workers; and the Dog and Crook, a reference to the many shepherds around when the pub was so-named.

ROPLEY

The earliest record of this place name dates from 1172 as Roppele. This is thought to come from a Saxon personal name suffixed by Old English *leah* and tells of 'the woodland clearing of a man called Hroppa'.

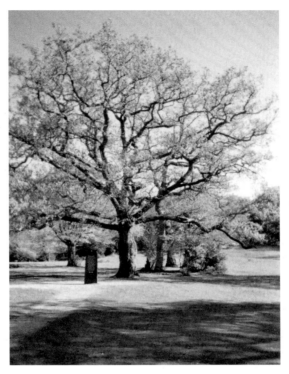

The Rufus Stone in the New Forest.

ROTHER (RIVER)

Listings of this name are found as Andlang scire in 956, Scyre in 975 and Schire in 1160, and have no connection to the modern name. Indeed this is from the Old English *scir* and describes 'the bright one'. The present name is taken from Rotherbridge in neighbouring Sussex, the process being known as back-formation.

ROTHERWICK

The record of this place from around 1100 as Hrytheruuica is little different from the original Old English *hryther-wic* and speaks of 'the cattle farm'.

The Falcon is more likely taken from the coat of arms of someone around here than to refer to a falconer, while the Coach and Horses would have been a coaching inn.

ROWLANDS CASTLE

In 1315 this name is found as Rolokescastel and in 1369 Roulandes Castell. This was originally 'the castle of a man called Rolok' featuring Middle English *castel* and an Old

French personal name. However, the true meaning was soon forgotten and the place name said to be associated with Roland, a medieval knight of legend.

ROWNHAMS

A name recorded in 1269 as Rowenham and in 1301 as Roghenham, from Old English and describing this as being '(at the) rough hemmed in land'.

RUFUS STONE

A place in the New Forest which was the site of the killing of William Rufus, the second Norman king of England. Hunting in the New Forest in 1099, the party were in pursuit of deer when an arrow released from the bow of Walter Tyrell was deflected by a tree and killed the monarch on the spot. The stone referred to in the name was not here until 1745, and the inscription on the modern piece of marble is clearly contemporary.

For a man known to have killed a king, albeit by accident, he still seems the most unlikely inspiration for naming a public house as has happened here with the Sir Walter Tyrell.

RUSHMOOR

Although this district name was apparently created following the administrative reorganisation of the 1970s, the choice was based on an historical name and one which appears as Rushe more in 1567. This would refer to 'the rushy marsh'.

CHAPTER 18

S

ST MARY BOURNE

Records of this name include Borne in 1185 and Maryborne in 1476. The basic name is from Old English *burna*, referring to 'the place at the springs' while the addition reminds us of the original dedication of the local chapel.

A minor name found here is that of Stoke, the most common place name in England and here referring to 'the dependent farm', a place created as a farming community to help feed the main body of the settlement.

Swampton is not the predictable name it would seem, for this came not from 'swamp' but is listed as Suantune in 1086 and Swanton in 1269. This seems to be 'the swan farm' and yet, although swans were eaten by the nobility of England, there is no suggestion that they were ever farmed or that there was ever a large enough market to make this a viable proposition. As alternative is that it could be Swan as a personal name but no record of this name exists. So we turn to 'swains tun', a name referring to 'countrymen or shepherds farmstead' and yet this does not seem to fit recorded history. Hence this may be a unique place name from Old English *swamm-tun* or 'the farmstead of mushrooms or toadstools', not that either would have been farmed as such but were often present here. Wadwick features a Saxon personal name with the Old English element *wic*, here 'Wada's specialised farm' is almost certainly a dairy farm.

A number of minor place names here have the element Wyke, this comes from Old English *wic* and describes 'the specialised farm'. Over ninety-five percent of these examples would refer to a dairy farm.

Nearby Binley is recorded as Benelega in 1184, Bynleghe in 1269, and Bienlygh, this name is derived from Old English *bean-leah* and refers to 'the woodland clearing where beans are grown'. There are suggestions that this may be a personal name in 'the woodland clearing of a man called Bynna', or perhaps *beona-leah* 'the woodland clearing where bees are seen'.

SANDLEHEATH

West of Fordinbridge is a region recorded in 1536 as Sandelheath and in 1590 as Sandhill Heathe. Here is a name referring to the 'heath of the manor of the sandy hill', although the modern region is not on sandy soil but on clay and shows the name was once applied to a nearby or larger area.

SARISBURY

During the reign of Edward I (1239-1307) this place near Fareham was known as Sarebury. No further mention of this place was made until 1538 when it appears in the modern form and although it may have been influenced by Salisbury there is no foundation for this theory and the origins of the name are unknown.

SELBORNE

From the Old English *sealh* or *sele-burna* this is a name telling us this settlement began life as 'the stream by the sallow trees or (a) sallow tree copse'. It is recorded as Seleborne in 903 and as Selesburne in 1086.

The name of Rhode appears here in the shape of Rhode Hill and Rhode Farm. It is a corruption of *rodu*, the Old English term for a tract of land cleared of vegetation and prepared for cultivation. The local name of Whitehill has no recordings of note, but is surely from Old English and describing the 'white hill' based on the chalk soils here. Temple Farm marks the former settlement of Temple Sothington, an early seventeenth-century farmstead of the 'south of the village' which was held by the Knights Templar.

SHALDEN

Records of this name begin in 1046 as Scealdeden, while Domesday offers Seldene. This is a name from Old English *sceald-denu* and describes the '(place at) the shallow valley'.

SHAWFORD

Old English *sceald-ford* is first seen as a place name here in 1208, as Scaldeforda, and telling us this was an ideal crossing point on 'the shallow ford'.

SHEDFIELD

Today it would seem this place name would refer to something we are used to seeing, literally 'the field with a shed'. However, the original Old English *scid-feld* features two elements which speak of neither a shed nor even a field in the modern sense.

The suffix here is the Saxon *feld*, a region of woodland cleared for the largely agrarian society of that era. While a field and a feld were basically the same within their boundaries, it is the boundaries themselves which are very different. Saxons did not habitually enclose their *felds* by woven hedgerows, that was a skill which had not yet developed. Wooden fencing came even later and barbed wire was not seen until the twentieth century.

The first element of *scid* is even more remote from a modern shed than *feld* is to field. The closest modern equivalent for *scid* would be planks. It is, however, not the meaning which is the problem but understanding what message is being conveyed. It is tempting to suggest this was where trees were brought having been felled and were split to form planks, effectively an early lumber yard with the name providing all the advertising required. However, it is possible the explanation is much less exciting and simply indicates a place where planks were used to provide a surface on which to walk. Note this is not necessarily a bridge across a stream or drainage channel, indeed if it was we would expect Old English *brycg* to feature. Instead a walkway across almost permanently muddy fields which were walked regularly might be being referred to. On a far grander scale walkways had crossed the bogs and wetlands of Somerset to the north-west since pre-historic times, so planking lain down to produce firm footing along a well-trodden path in Hampshire is perfectly plausible.

Either definition here is a delight for the author, for each produces a snapshot of life in Saxon times. Indeed it is easy to image the wife and child of the shepherd or herdsman walking the planked walkway across the muddy field, carrying food and drink for the man of the house and thus allowing him to remain at his post watching over the livestock. Or perhaps we envisage a scene where wedges are being repeatedly driven into the grain along the trunk of a felled tree by a number of men, producing a split and eventually shearing off a plank. This is not the neatly trimmed and finished lumber of today but effectively a large splinter from the bulk of the wood, although the high level of the skills involved enabled quite smooth and even surfaces to be produced.

SHEET

Found as Syeta around 1210, this place name is derived from Old English *sciete* and refers to 'the projecting piece of land, the corner or nook'.

SHERBOURNE ST JOHN

There can be no doubt this is from Old English *scir-burna* and describes the '(place at) the clear or bright stream'. However, early forms show this name was not always as simple as today, for while Domesday gives the name as Sireburne and Sireborne later records are found of Shireburna Johannis (Sherborne St John) in 1167 and Schireburne Monachorum (Monk Sherborne) around 1270. The later record features Latin *monachorum* or 'of the monks' a reference to the priory here, while the earlier twelfth-century version refers to the family of Robert de Sancto Johane who was known to be here by the thirteenth century and probably earlier too.

Here is the minor name of the Vyne, a name which has remained unchanged since 1531. This name is claimed to have been the earliest coined specifically for a house, this being a sixteenth-century country house built for Lord Sandys, Lord Chamberlain of Henry VIII. The Close is a development from the 1950s and an early example of a developer's name. Spring Close is another example of this.

Beaurepaire Park is undoubtedly of Old French origin, but has been influenced by English to such an extent it would be fair to suggest this is an unofficial Anglo-Norman *beau-repaire* 'the fine retreat'. Without the English influences this would have evolved to become more like Belper or Beaper.

SHERFIELD ENGLISH

Listed as Sirefelle in Domesday and coming from Old English *scir-feld*, this place name tells us it was 'the bright open land' which is understood as referring to the sparseness or absence of vegetation. The addition, to distinguish it from the following entry, points to this manor being held by the le Engleis family in the fourteenth century.

SHERFIELD ON LODDON

Found as Scirefeld in 1179 this, as with the previous name, is 'the bright open land' from Old English *scir-feld*. In a land where vegetation dominated the landscape, a region where such was sparse would have appeared very bright. The addition here is from the Celtic river name thought to be describing 'the muddy stream'.

Goddard's Close is a developer's name, taken from a former resident. The Four Horseshoes is a pub name referring to the blacksmiths nearby. The more common version is the Three Horseshoes as the suggestion is usually of a horse needing a replacement shoe, so perhaps this is offering four new shoes.

SHIPTON BELLINGER

Records of this name begin with Domesday's Sceptone, while the fourteenth-century record of Shupton Berenger is is the first evidence of the addition, necessary for such a common basic place name as Shipton. Here the Old English *sceap-tun* tells us it was 'the sheep farm', which was the manorial holding of the Berenger family by at least the thirteenth century.

Minor names here include Snoddington, recorded in 1086 as Snodintone and as Snodintun in 1269. This is an Old English place name referring to 'Snodd's farmstead'.

SHIRLEY

A name found in many counties of Saxon England and nearly always referring to 'the shire clearing' from Old English *scir-leah* and is recorded as Sirelei in 1086. Old English *scir* or 'shire' referred to a district and thus this may have been a meeting place for the

area. Indeed, despite this being a fairly common name, each is quite distant from another which not only means there is no need for a distinctive second element but may also be further evidence of a central meeting place within an area.

SHIRRELL HEATH

First found as Scirhiltae in 826, this name comes from Old English *scir-hylte* and is understood to refer to 'the bright or sparsely wooded grove'. The addition of heath did not appear before the seventeenth century.

SHOLING

A recording of 1251 as Sholling probably shows this to be from Old English *sceolh-ing* or 'the uneven or sloping place'.

There can be no doubting the sporting associations with the names of the two pubs here, the Bulls Eye and the Winning Post.

SILCHESTER

Domesday's record of Silcestre is little different from today's version. This seems to show two elements and is Old English or Saxon *siele-ceaster* translated as 'the Roman stronghold by the willow copse'. However, during the second century Roman occupation this place is recorded as Calleva, the Celtic name for this settlement and one which speaks of 'the place in the woods'.

SLEAFORD

A name which was thought to be derived from 'the ford on the River Slea'. This, however, is not the case for the river takes its name from the place. Records of this name include Sleyford in 1245 and Slayford in 1336, this latter telling us exactly where the name comes from, for there is no doubt this is 'the killing ford'. Just what happened here to merit such a name will probably never be known. If we were to speculate, then perhaps this was a natural funnel for travellers to cross the river and, as such, provided a reliable supply of potential victims for robbers and murderers.

SMANNELL

A name found as Smethenhulle, Smethull and Smanhill between the eleventh and seventeenth centuries and derived from Old English *smethe-hyll* or the '(place at) the smooth hill'. Today this gentle rise would never be described as a hill, this is not that the conception of a hill has changed but the usage of the word.

SOBERTON

Domesday records this name as Sudbertune and speaks of 'the southern outlying farmstead' from Old English *suth-bere-tun*.

Minor names here include that of Hoe or 'the hill-spur of land' and, with an obvious addition, East Hoe.

SOLENT, THE

The earliest surviving record of this name dates from 731 as Soluente. However, this is undoubtedly at least Celtic in origin and probably much earlier. The antiquity of the name is intriguing and at the same time frustrating, for it is so old it comes from a group of languages with no written form and the meaning is unknown.

SOMBORNE (KINGS, LITTLE, and UPPER)

Three places which have a common origin in Old English *swin-burna* and speaking of 'the pig stream'. This name, seen as Swinburnan in 909 and Sunburne in 1086, most likely refers to an area where pigs were the dominant livestock and to the stream which flowed through it. There is no evidence to suggest a crossing point or other connection with herds of swine. There can be no doubt these were domesticated creatures, for wild pigs were referred to as boars as they still are today.

The additions here, while common, are rather unusual in relation to one another. King's is clearly a possession of the Crown, Upper a reference to it being further upstream and Little the smallest of the three.

SOPLEY

Found in Domesday as Sopelie, this name is derived from a Saxon personal name followed by Old English *leah*. This speaks of 'Soppa's woodland clearing'.

SOUTHAMPTON

A place recorded as Homtun in 825, Suthhamtunam in 962 and Hantone in Domesday. There can be no doubt of the origin of this name, Old English *hamm-tun* referring to the 'farmstead in a promontory' and the addition says it is to the south. However, this addition has never been adequately explained. The popular explanation is that it was at the southern end of a road running to Northampton in the Midlands. Part of the evidence came from a record from Abingdon, Oxfordshire, roughly equidistant between Northampton and Southampton. This explanation, however, is open to various objections, the main one being that the settlements are too far apart for this to be tenable. It would have been a significant undertaking to travel between the two places in Saxon times. There was, however, a Northampton much closer to home, recorded as

The district of Highfield in Southampton.

Northametone in 903, which is still here in Hampshire in the twenty-first century but whose name has been corrupted to Northington. It would seem to the author that this is a far more logical explanation than a link to a distant city in the Midlands.

Belvidere is a region of the city on the west bank of the Itchen, which must have once offered fine views over the river but is somewhat swamped by modern construction today. The name refers to a belvedere, a small raised tower offering views of the surrounding area. In the early eighteenth century the Earl of Peterborough built a new home which he called Bevis Mount, which itself was taken from the Bevis Valley on the estate. It is probably a reference to the Old French for 'the beautiful view' and has since also been adopted by the modern development of Bevois Town. Conversely, this modern estate has a Peterborough Road named after the man who provided the Bevois name.

The area leading up to Southampton Common is known as Hill, which gave its name to Hill Lane and has obvious origins. On Southampton Common is an place known as Cut Thorn. Historically it was always called Cutted Thorn, the modern form is probably only due to present-day grammar. Undoubtedly this is the same as Copythorne, 'the pollarded hawthorn', although here the reference seems certain to have been to a marker for either a meeting place or perhaps a boundary. The district of Highfield takes its name from a local eighteenth-century mansion, whose name probably came from 'the high or chief field'. Hoburne was a local manor whose name comes from Old English *woh-burna* or 'the winding stream', yet today the local Bure Brook does not display any remarkable bends.

Lansdowne Hill commemorates the second Marquis of Lansdowne who, during his tenure (1805-9), built a ghastly Gothic folly here which was pulled down after his death. The Polygon is an area which was to be developed at the end of the eighteenth century for the richer residents of Southampton. The block of houses were to form a regular dodecagon, with their back yards tapered and leading to a hotel which was to be the focal point for the residents' grand social occasions. However, by 1773 the scheme ran into acute financial problems and was never completed, and today the only remnants of the scheme is the road and the hotel which took the name. The suburb of St Denys is derived from the local church being dedicated to St Denys, the patron saint of Paris. Banister's Park reminds us of the Banastre family who owned land here in the fourteenth century.

Street names in Southampton come from a variety of sources, all of whom have had some connection with the city. Earls Road, Mordaunt Road and Peterborough Road, all named after the Charles Mordaunt, 3rd Earl of Peterborough (1658-1735). Here is a man who has been described as an 'errant knight' and 'eccentric genius', soubriquets he may have deserved even though he had also served his country as an admiral, a general, an ambassador and, in his later years, an author.

Other members of the nobility have given us: Aberdeen Road recalling George Hamilton-Gordon, 4th Earl of Aberdeen and Prime Minister 1852-55; Russell Street, named after Lord John Russell who served as Prime Minister for eight short months from October 1865; Cambridge Road that remembers Prince George William Frederick Charles, 2nd Duke of Cambridge and Commander-in-Chief of the British Army from 1856-95.

Edwina Close honours the memory of Edwina, Lady Mountbatten. She was born Edwina Cynthia Annette Ashley and died in February 1960 at the age of fifty-eight. Mountbatten Way recalls her husband, Earl Mountbatten of Burma who resided at Broadlands near Romsey; Grosvenor Square and Grosvenor Road refer to Earl Grosvenor, Duke of Westminster. Paulet Close reminds us of Sir William Paulet, 1st Marquis of Winchester (1483-1572); and York Road reminds us of George, Duke of York, who was to become George V.

Public figures were the inspiration behind the following: Bond Road (Liberal politicial Edward Bond), Campbell Street (General Sir Colin Campbell (1792-1863), appointed governor-general of India in 1847), Frobisher Gardens (Sir Martin Frobisher (1535-94), who made three voyages to the New World in search of the Northwest Passage), Hardwicke Close (Actor Sir Cedric Hardwicke KBE (1893-1964)), Havelock Road (Sir Henry Havelock (1795-1857), hero of the Indian Rebellion of 1857), Hinkler Road (Australian aviator Bert Hinkler), Herbert Walker Avenue (General Manager of the LSW Railway), Irving Road (Actor Sir Henry Irving (1838-1905)), Kingsley Road (professor, historian and novelist Charles Kingsley (1819-75)), Leroux Close (Jacob Leroux, architect), Livingstone Road (explorer David Livingstone (1813-73)), Scottish explorer and missionary), Longmore Avenue and Longmore Crescent (Surgeon General Sir Thomas Longmore (1816-95)), Northbrook Road (merchant banker Sir Francis Baring, Baron Northbrook (1740-1810)), Onslow Road (General Denzil Onslow (1770-1838), British Army officer who also played cricket for the MCC), Shayer Road (artist William Shayer (1787-1879)), Taranto Road (Battle of Taranto, fought on 11 November 1940), Tebourba Way (Battle of Tebourba, fought in Tunisia in December 1942) and Thorndike Close and Thorndike Road (actress Dame Sybil Thorndike (1882-1976)).

Local inviduals and places commemorated by street names include Arthur Road (landowner Arthur Atherley), Ashby Road (Hooper and Ashby, builder's merchants), Asylum Road (the Hampshire female orphan asylum), Burton Road (the Revd Arthur Daniel Burton), Charles Knott Gardens (Charles Knott, who built the ice rink here), Collier Close (greengrocer Joseph Collier), Crowther Close (Wally Crowther, former landlord of the Spa Tavern), Dowling's Road (Henry Dowling was a local market gardener); Fanshawe Road (the Revd Charles Simon Faithful Fanshawe (1806-73)), Gibbs Road (after the Gibbs baking family), Arliss Road (actor George Arliss), Hinton Crescent (W.G. Hinton & Sons, builders), Janaway Gardens (Henry Janaway, clerk to the council in the 1880s), Lankester's Cut (Lankester's Engineering firm), Nomad Close (Bitterne Nomads Football Club), Priory Avenue and St Deny's Road (St Denys Priory), Tankerville Road (Tankerville Chamberlayne (1843-1924), JP and MP for Southampton, rugby player, footballer, yachtsman, rower, who also represented Hampshire at cricket), White's Road (developer John White), Wilson Street (the firm of T.S. Wilson, iron and brass founders), Wood Close (conductor Sir Henry Wood (1869-1944)), and Wycliffe Road (John Wycliffe, first man to translate the Bible into English and who was declared a heretic by the Catholic Church).

Of course Southampton has always had a history linked more to the sea than the land. Thus it is no surprise to find streets reflecting this long association. Anderson's Road (Arthur Anderson, founder of P&O), Defender Road (the famous yacht *Defender*), Endeavour Close (Captain Cook's ship of that name), Exeter Road (HMS *Exeter*, which fought at the Battle of the River Plate), Foy's Corner (S.H. Foy and Son, shipbuilders), Hood Road (HMS *Hood*, Royal Navy battlecruiser), Ransom's Terrace (shipbuilder John Ransom), Shamrock Road (the famous yacht *Shamrock*), and Vanguard Road (HMS *Vanguard*).

Bramley Crescent, Laxton Close, and Worcester Place were all named after varieties of apple.

Southampton's pubs are named from a variety of sources. The Bittern is more a place name than a reference to the bird, as is the Bevois Castle. The Lock, Stock and Barrel suggests everything is available here; the Old Fat Cat suggests this is the place for the rich; while alliteration rather that etymology is used in the names of the Ferryman and Firkin, the Frog and Frigate, and the Peg and Parrot. The Le Tissier Arms remembers Southampton Football Club's most naturally gifted player and a laudably loyal member of the club, the Cowherds Inn was built where the herdmen's huts once stood, the Giddy Bridge shows a gentleman crossing a very precarious wooden bridge, the Angel of the South (as in Southampton) alludes to it being akin to the landmark known as the Angel of the North. Finally, the Saxon Inn reminds us of the ancient Kingdom of Wessex, which is also referred to by the name of its ruler in the King Alfred.

SOUTHSEA

This is a very late name, not found before 1600 when it is recorded as Southsea Castle and is self-explanatory. The castle in question was constructed on the orders of Henry VIII in 1540, and the town grew up around it.

Undoubtedly patriotism is the message of the pub named the Red, White and Blue; Charles II's Favourite is commemorated by the Nell Gwynne, the Alma Arms is named after a major engagement of the Crimean Wars, and the Tut 'n' Shive refers to the bung used to stop up the cask of ale.

SOUTH TIDWORTH

In 990 this name is recorded as Tudanwyrthe, which by Domesday in 1086 is Todeworde. Another Old English place name which comes from a Saxon personal name with *worth* and tells us this was 'the enclosure of a man called Tuda'. The addition is to distinguish this from North Tidworth in neighbouring Wiltshire.

SOUTHWICK

No record of this name survives before its 1140 appearance as Sudwic. This is undoubtedly from Old English *suth-wic* and tells us of 'the southern specialised farm'. Almost without exception the speciality of such farms were their dairy herds.

Wanstead is recorded as Wenstede in 1201 and Wanstuda in 1212. It takes its name from the Old English *wen-stede* or the 'place of the smooth hill'.

SOUTH WONSTON

Records of this name are found in 901 as Wynsigestune and in Doemsday as Wenesistune. Here the name refers to 'the farmstead or tun of a man called Wunsige'.

SPARSHOLT

A name which appears as Speoresholte in 901 and which has been explained several ways. This may be Old English *spearr-holt* and refer to 'a spar or rafter wood' and this was where the raw material was obtained to produce such items. However this first element is uncommon in place names, and the alternative *spere-holt* meaning 'the wood of the spear' has been suggested as a possible origin. This could also have two meanings, both equally plausible. Either this is simply a place where wood was obtained to produce spears, or perhaps the answer is more complex and this is where spears were embedded point-up in a pit to form a trap into which animals such as deer were driven. If the latter is the case it again produces an image of life in centuries gone by, albeit a somewhat gory picture.

Minor place names here include Lainston, originally thought to have been 'Leofwine's farmstead'.

SPITHEAD

Although this name is not recorded before the seventeenth century, there can be no doubt it existed well before then for it features the Old English elements *spitu-heafod*, meaning 'the headland of the sand-spit or pointed sandbank'.

STEEP

From the Old English *stepe*, and indeed recorded as Stepe in the twelfth century, this name speaks of 'the steep place'.

STEVENTON

Listed as Steveneton in Domesday, this name has two potential definitions. Either this is Old English *styfic-ing-tun* and 'the farmstead at the place of tree stumps' or the first element features a Saxon personal name and the meaning is 'the farmstead associated with a man called Stifa'.

Wheatley's Close was named by a developer and taken from an old field name.

STOCKBRIDGE

A name found in other counties and always from Old English *stocc-brycg* or 'the bridge made of logs'. Its earliest surviving record is as Stocbrugge in 1221.

At Stockbridge public houses include the Mayfly, a major food source for the fish; the Peat Spade, designed to cut turves of peat which were burned as fuel; and the Three Cups Inn, which is simply an invitation to partake of a drink within.

STOKE CHARITY

Surviving records of this name are numerous and evolve from Stoches in 1086, to Eledestoke in 1256, Elledestok in 1276, Stokecharite in 1270, Eldestoke in 1276, Oldestoke in 1364, and Old Stoke Charitie in the fourteenth century. This place began life as Old English *stoc*, or 'dependent or secondary settlement', later the addition of *eald* or 'old' distinguished this from other places of this name. Eventually the name of the Lord of the Manor, one Henry de la Charite in 1276, became the distinguishing element, although in the fourteenth century both the additions are used.

STONEHAM (NORTH and SOUTH)

Both are derived from Old English *stan-ham* or 'the stone homestead', whose meaning is 'on stony ground' rather than 'built of stone'. In earlier times these were the manors held by Hyde Abbey and the Bishop of Winchester, and North Stoneham was previously Abbot's Stoneham and South Stoneham was Bishop's Stoneham.

The ancient tithing of Allington in South Stoneham derives its name from 'the farmstead associated with a man called Ealda', with the Saxon personal name suffixed by Old English *ing-tun*. Bassett is a region of Stoneham which developed in the eighteenth century, built for the affluent members of Southampton society. As a place name it seems it can only have come from a family named Basset who were here in the early fifteenth century.

STOUR (RIVER)

Often referred to as the Hampshire Stour, this is one of five major rivers in England of this name, from a Celtic river name meaning 'the clear one'.

STRATFIELD SAYE

A basic name which comes from Old English *staet-feld* and refers to 'the open land by the Roman road'. Recorded as Stratfeld in 1060 and Stradfelle in 1086, the addition is not seen before 1277 as Stratfeld Say. This addition comes from this manor being held by the de Say family, known to be here by at least the thirteenth century.

STRATFIELD TURGIS

As with the previous name this is 'the open land by the Roman road', with the addition referring to it being held by the Turgis family and recorded as Stratfeld Turgys in 1289.

STRATTON (EAST and WEST)

A name from Old English *straet-tun* and describing 'the farmstead on a Roman road'. Records of these names include Strattone in 903 and Stratune in 1086, while the recent additions are self-explanatory.

STUBBINGTON

With only Domesday's record of Stubintone to assist us, it is difficult to discern between two equally plausible origins. This may be from a personal name with Old English *ing-tun* giving the meaning of 'the farmstead associated with a man called Stubba'. However, it is more logical to expect the name to reflect a description of the place as is the case with Old English *stubbing-tun* and giving us 'the farmstead at the clearing with many tree stumps'.

The Golden Bowler public house suggests the cricketer is of a very good standard; the Cuckoo Pint is a plant, a species of arum, but which also alludes to a measure of ale.

SUTTON SCOTNEY

Records of Sudtune in 1086 and Suttun in 1235 show this was simply 'the southern farmstead' for some time. Sutton is a common place name which requires a second distinguishing element. Here the name comes from its possession by Walter de Scotney by 1235, whose family took the name of their home town of Etocquigny in Normandy.

In 909 a record of Hundatun is found, which by 965 had become Hundetun. In the twenty-first century this is seen as Hunton and reminds us that this place began its life as 'dogs farmstead' which should probably be seen as 'kennels'.

SWANMORE

There is no confusion where this name is concerned, here is Old English *swan-mere* or 'the pool frequented by swans' and recorded as Suanemere in 1205.

SWANWICK

Similar to the previous name but also quite different in origin. Here the Old English *swane-wic*, recorded as Suanewic in 1185, refers to 'the specialised farm of the herdsmen'. As noted elsewhere the term *wic* or 'specialised farm' is invariably a dairy farm and, considering the first element here, cannot be anything else.

At Swanwick the Spinnaker public house is named after a part of the rigging on a sailing ship, the Doghouse allows the husbands of nagging wives the opportunity to be scolded (be in 'the doghouse') and still be able to enjoy their favourite tipple.

SWARRATON

Records of this name are found as Serueton in 1207, as Sherueton in 1242 and as Swarweton in 1250, and yet it is a sixteenth-century copy of a tenth-century document which seems to offer the most plausible origin. Here the name is Swerwetone is recorded which seems to refer to Old English *swearth-tun* or 'the farmstead where animals skins or pelts were available'. Certainly this would have been a profitable venture and, provided supplies could be maintained, one which would have guaranteed business for many years.

SWAY

Recorded in Domesday as Sueia this is probably a Saxon river name meaning 'the noisy stream', however there is also a chance it could refer to Old English *swaerth* meaning 'swathe, or track'.

Minor names in this area include Arnewood, from Old English *eana-wudu* meaning this is 'the eagles wood'.

Street names in Sway include Kitchers Close, which had previously been known as Kittiers since the seventeenth century and a reminder of a former resident. Crittall Close remembers Samuel W. Crittall, who served as Parish Councillor 1934-44 and whose father was miller at Flexford Mill. William Paul, who had earned a good living by manufacturing sieves for the local gravel pits, gave his name to Pauls Lane. A more contemporary name is that of Heron Close, named after Heron Homes who developed this area.

However, surely the most deserving personality commemorated was the man who gave his name to Hyde Close. In 1891 Charles Hyde was the local blacksmith, ten years later he was the school attendance officer, was soon serving as Overseer and Clerk to the Council, and from 1907 was elected to Parish Council on which he was to serve for the next fifteen years. The family also saw tragedy, for their son Oliver was the first villager to become a casualty of the First World War. Aged thirty-six he

was serving as Petty Officer in the Royal Navy aboard HMS *Bulmark* and was based at Sheerness as part of a team who were loading ammunition. There was an explosion and Oliver Hyde died instantly.

SWAYTHLING

Despite the similarity with the previous entry, they are not related. The place name is found as Swaethelinge in 909 which was thought to come from a Celtic term of unknown meaning. However, in recent times a suggestion of Old English *swaethling* has produced the possible meaning of 'misty stream'.

SYDMONTON

Domesday lists this place name as Sidemanestone, which undoubtedly speaks of 'Sidumann's tun or farmstead'.

Part of the chalkland here is marked on maps from as early as 1432 as Watership Down. The name of the famous book by Richard Adams, written in 1972, came from this. There is also a record of the place as Watershipe from 1432. The name describes an 'artificial watercourse, a conduit'. Hence there is an irony here that a book which tells the story of how the natural home of the rabbit (actually a species introduced by the Normans in the eleventh century) is being destroyed in the name of progress by man – when the title of the book, and thus the home of the rabbits, is derived from a place named from a man-made watercourse!

CHAPTER 19

T

TADLEY

Records of this name begin with Tadanleage in 909, a name which comes from a Saxon personal name with Old English *leah* and describes this place as 'the woodland clearing of a man called Tada'.

Mulfords Hill is a street name which recalls John Mulford, a local benefactor who died on 7 January 1814 aged ninety-four. During his lifetime he gave time and money to many local projects and causes. The local pub is the Queen's College Arms, the land here belongs to Queen's College, Oxford and the sign depicts their coat of arms.

TANGLEY

Records of this name are found as Taseburc in 1086 and is probably 'the stronghold of a man called Taesa', with the Saxon name suffixed by Old English *burh*. Here the River Tan is named from the place in a process known as back-formation.

TEST, RIVER

This name has proven an enigma for toponomists, for the early forms seem to contradict everything that should be expected from any Celtic tongue, while the suggestion of it being a Germanic or Saxon name can be discounted. Records of Terstan in 877, Taerstan Stream in 1043, Terste in 1234 and Test in 1425 may show the evolution but offer no assistance when it comes to defining it.

While many river names have similarities – Thames, Teign, Tame, Teme, Tene, and Tamar all have a similar origin – they are not related to that of Test. The only river name which has any similarity to the ancient forms is that of the Trent, which is known

to be 'the wanderer' and used to describe it as being likely to flood. However, the Test has no more tendency to flood than any other tidal estuary and thus the origins of the name will remain unknown.

TESTWOOD

Recorded in Domesday as Lesteorde, and as Terstewode in 1185, this name refers to 'the wood by the River Test'. This is a Celtic or even pre-Celtic river name of obscure origins with Old English *wudu*. Domesday's record with its initial 'L' can be discounted as erroneous.

THEDDEN GRANGE

Records of this name date back to Domesday as Tedena and as Thetdene in 1234. This name is derived from the Old English *theote-denu* and describes 'the valley with a waterpipe'. This is probably a reference to an irrigation channel or some means of providing water for livestock.

THRUXTON

Found in 1167 as Turkilleston this place refers to 'the farmstead of a man called Thorkell'. Here Old English *tun* follows an Old Scandinavian personal name. It is most unusual to find the name of a Norseman in what was once Saxon-dominated England, hence this is likely to have been a name which had not existed much before the first record.

The White Horse public house shows part of a coat of arms, however it is difficult to know which as this device is used in the the arms of the Guilds of the Carmen, Coachmen, Farriers, Innholders, Saddlers and Wheelwrights, plus innumerable families.

TICHBORNE

Records of this name are found as Ticceburna in 909, Ticceburnan in 938 and Ticheburne in 1235, where the tenth-century records point to Old English *ticcen-burna* or 'the kid stream'. The reference here is clearly to young goats, although there is a slim chance it is a nickname.

TIMSBURY

From the Old English combination of *timbert-burh*, and recorded as Timbresberie in Domesday, this place name speaks of 'the wooden fort of the manor'.

TIPTOE

This name is not found before 1555, where the forms are of little help in showing the etymology of what is apparently a very odd place name. However, it is known that the lords of the manor at this time were the Typetot family, indeed they are first mentioned as early as the thirteenth century.

The Plough Inn is a favourite pub name in rural areas.

TISTED (EAST and WEST)

This place name is recorded in 932 as Ticcesstede and as Tistede in 1086. Undoubtedly this comes from the Old English *ticce-stede* describing 'the place where young goats are kept'. Clearly this was once one settlement with one an offshoot of the other, hence the later additions.

TITCHFIELD

Recorded as Ticefelle in Domesday in 1086, this name comes from Old English *ticce-feld* and describes 'the open land where goats are kept'.

One minor place name, Fontley Road, is derived from Old English *funta-leah* and describes 'the woodland clearing of the spring'. The spring is mentioned during the Roman era and, almost 2,000 years later, still produces great volumes of fresh water. Posbrook is a name seen a number of times on local maps, it is derived from a settlement listed as Possebroc in 1202 speaking of 'Possa's brook'.

Segenworth, also recorded as Segensworth, is first seen as a place name in 982 as Suggincgwyrthe, an Old English name speaking of 'Sugga's enclosure'.

Public houses here include the Wheatsheaf Inn, a rural image and one which is instantly recognised; the Queen's Head, telling us an early owner or landlord was a royalist; and the Fisherman's Rest an offer to any angler to seek refreshment within.

TOTTON

With a listing of Totintone in Domesday, this name comes from a Saxon personal name followed by Old English *ing-tun* and refers to 'the farmstead associated with a man called Tota'.

The district of Hammond's Green has come from the name of Hammond's Farm, with a William Hammon found in neighbouring Eling in 1588. Rushington is not seen until the sixteenth century as Russhyngton and Risshington alias Rumbridge. This second record shows the now lost place name of Rum Bridge, which is still applied to the bridge, while the basic name refers to this as 'the farmstead of the rushy ground'.

The sign at the Salmon Leap pub shows a salmon climbing a waterfall on its journey to its spawning grounds.

TUFTON

This name undoubtedly comes from a Saxon personal name with Old English *ing-tun* and meaning 'the farmstead associated with a man called Toca or Tucca'. It is recorded in Domesday as Tochiton.

TUNWORTH

The Domesday record of Tuneworde shows this to be from a Saxon personal name and Old English *worth* and is telling us that this was 'the enclosure of a man called Tunna'.

TWYFORD

A name found in a number of counties in England, always from Old English *twi-ford* and referring to the 'double ford'. This does not refer to two fords in parallel but in sequence to cross a wide stretch of wet ground and it is recorded as Twifyrde in 970 and Tviforde in 1086.

The Phoenix Inn is a name which is always applied to pubs which, like the fabled bird, have 'risen from the ashes'. This could refer to a refurbishment as much as a rebuild after a fire, while it should never be thought the previous life of the premises was inevitably as a pub. The Bugle Inn most often refers to the horn carried by the guard on the coaches, used much the same way as a car horn is today.

TYTHERLEY (EAST and WEST)

Found in Domesday as Tiderlei this place name is derived from Old English *tiedre-leah* and describes 'the young wood or clearing', referring to new growth and suggesting the region had previously been cleared. Furthermore the additions, while self-explanatory, will also mean that one was an offshoot of the other.

CHAPTER 20

U

UPHAM

There is no surprise in finding this is derived from Old English *upp-ham*, or 'the upper homestead'. However, it is unusual to find that the name was recorded in its present form as early as 1201.

The Brushmakers Arms is an unusual name, not least because there were few members of the trade which involved producing a brush or besom from hazel twigs bunched around a thicker pole and which is today only used for clearing leaves.

UP NATELEY

Early records of this name include Nataleie in 1086 and Upmateley in 1274. The basic name is from Old English *naet-leah* and describes 'the wet woodland clearing'. Here the addition is from Old English *upp* meaning 'higher up' which is required to distinguish this from Netley Marsh, despite the slight difference in the modern spellings. Netley Scures is given a distinct name from the late thirteenth century when the place was held by the de Scures family.

St Stephen's Close is a developer's name from the 1950s, referring to the dedication of the local church.

UPPER CLATFORD

Recorded as Cladford in the eleventh century, this name is derived from the Old English *clate-ford* meaning 'the ford where burdock grows'.

The local pub recalls the history of sheep farming in this area, for the name of the Crook & Shears features the crook of the shepherd and the shearer's only tool.

UPPER PENNINGTON

There is just one early record of this name, as Penyton from the twelfth century and from Old English *pening-tun* or 'the farmstead paying a penny rent'.

To the north-east of the settlement is a farm named Batchley. In the late eleventh-century Domesday records this as a separate manor named Beceslei, later seen as Bachesle and Bacchesle, and coming from 'the woodland clearing of a man called Baecci'.

UP SOMBORNE

Taking its name from the tributary of the River Test, this is the '(place on) the pig stream'. The addition of Up refers to its position higher up the valley and distinguishes it from Little Somborne and King's Somborne to the west and north-west respectively.

UPTON GREY

For an 'up tun or farmstead' Upton Grey is odd in being actually lower than the surrounding land. True, there is a barely distinguishable rise when approaching from Hoddington to the south, yet this surely cannot be the meaning here. In fact unless the suggestion is 'up' in a hierarchical sense the meaning is completely lost. The addition is known however, for it was acquired from one John de Grey in the thirteenth century, the family taking their name from Graye in Normandy.

Locally, the area known as Hoddington, a hundred listed in Domesday, is named from the 'farmstead associated with the family or followers of Hoda'.

CHAPTER 21

V

VERNHAM DEAN

Recorded as Fernheam in 1210, this name comes from Old English *fearn-ham* and describes the 'homestead where ferns grow'. The addition here, which comes from Old English *denu*, means 'valley'.

CHAPTER 22

W

WALLINGTON

Records of this name include Waletune in 1233, a name which comes from Old English *wala-tun* and speaks of 'the farmstead of the Britons'.

WALLOP (MIDDLE, NETHER and OVER)

Early records of this name are limited to Wallope in Domesday. This has three potential Old English origins. This is either *wella-hop* meaning 'the valley with a stream', *waell* meaning the '(place at) the wall', or perhaps *walu* '(place at) the ridge or embankment'. The meaning of the additions are obvious.

Nearby Danebury Hill is a name given to an earthwork first recorded as Duwnebury Hill in 1491, which has no connection with Denmark but is 'the hill fort of the downs'.

WARASH

The only early record of note is from 1272 as Weresasse. Either this is Old English *wer-aesc* and 'the weir of or by the ash trees' or the first element is the personal name *Waer*.

Public houses here include the Ferryman, and a ferry here would have reduced a journey dramatically in the past; while the Great Harry is also related to the water for it was a name used by the sailors to describe a galleon built in 1514 which was officially known as *Henry Grace à Dieu* or 'Henry, thanks to God'.

WARBLINGTON

A name which tells us this was 'the farmstead associated with a woman called Waerblith', with the personal name followed by Old English *ing-tun*. The name is recorded as Warblintone in 1086 and Warblinton in 1186.

WARNBOROUGH (NORTH and SOUTH)

The additions here are obvious and the two places historically linked, recorded as Weargeburnan in 973 and Wergeborne in 1086. It has been suggested that this is from Old English *wearg-burna* which speaks of 'the stream where criminals were drowned'. If this is the correct origin it must have been a most brutal way of disposing of the felons, hardly a humane method of execution, which makes one wonder as to the nature of their crimes. However, there is also the idea that *wearg* may not have been the original first element, but that this represents 'wolf' and therefore this name speaks of 'the stream of the wolves'.

Local pubs include the Anchor, more often related to the church than the sea, symbolising that your faith will forever be an anchor throughout life. It also provides a simple and easily recognised symbol. The Jolly Miller is a welcoming name, the Poacher is unlikely to refer to one who preyed on the lord of the manor's game but more likely stems from the folksong *The Lincolnshire Poacher*.

WARNFORD

Found as Wernaeford in 1053 and Warneford in 1086, this appears to be from Old English *waerna-ford* meaning 'the ford frequented by stallions'. However, the first element of this ford across the Meon may be the Saxon personal name *Waerna*.

WATERLOOVILLE

Quite a recent name which would not have been known before the battle of 1815, after which it was named.

Public houses here include the Falcon, which does sometimes refer to the sport of falconry but is more likely to be heraldic. It appears in many coats of arms including those of Elizabeth I and William Shakespeare. The Centurion is a name associated with war and the army, in olden times the Roman soldier and in the twentieth century the tank.

WEALD, THE

Found as Waldum in 1185, this name comes from Old English *weald* and refers to 'the woodland or forest'.

WEEKE

Listed as Wike in 1248, this name comes from Old English *wic* which is properly defined as 'a specialised farmstead'. Normally this would be said to be a dairy farm, yet without a preceding element this may not be the case and it would be pure speculation to suggest anything else.

WELLOW (EAST and WEST)

Recorded in 880 as Welewe and as Welew in 1086, this name comes from Old English *welig* and refers to the '(place at) the willow tree'. The additions are self-explanatory.

To the south of the main body of West Wellow is the region known as Canada and which gave its name to Canada Road. Looking at the modern map it is quite evident how this outlying region of the parish fills a wedge of unforested land in the New Forest. Indeed it is simply because it was so far outside the main body of the parish that it got its name. Known as a 'remoteness' name, it was common in the seventeenth and eighteenth centuries to name the most distant corner of the parish after a far corner of the then known world. In the middle of the eighteenth century Canada was much in the news and would even have filtered down to the working man who, facing a long walk to work, jokingly likened this part of the parish as being as distant as Canada.

Embley was a separate manor in Domesday, and later the Embley Park Estate was all that remained of the name. The house was one of the childhood homes of Florence Nightingale, and it was here in 1837 that the seventeen-year-old Florence first experienced what she would later describe as a Christian divine calling which led to her entering nursing. Embley means 'the level woodland clearing'.

The name of the local pub is the Red Rover, the name given to a famous coach in the days when pubs were the stopping places along coaching routes.

WEST END

A name not found before 1607 when it appears as Westend. There can be no dispute that the reference is to it being 'the western place', however just what it was 'west' of is unclear.

WESTON COLLEY

Here the basic name refers to it being 'the western farmstead', a reference to its location with respect to Micheldever. The addition here, while it may seem to be a family name at first glance, is more likely to be a lost place name and one which we could only guess at as there is not a single record of it. It may be that this is 'the charcoal woodland clearing' from Old English *col-leah*, for there is a Black Wood near here.

WESTON CORBETT

The basic name of the 'western farmstead' is joined here by Corbet, the name of the family who held this manor and who were here by 1203. It is recorded as simply Weston in 1203.

WESTON PATRICK

A third 'western farmstead', here with the addition of the name of one Paterik de Chaworces who was lord of this manor by 1257. It is recorded as simply Westone in 1086.

WEY, RIVER

A name which has proven difficult to define, indeed the only thing anyone seems to be able to agree on is this is that it is a very ancient name indeed. Records start in the ninth century with forms such as Waie and Wegan, which may be seen to be related to the Wye of neighbouring Dorset and the Wye tributary of the Severn. Any suggestion of this being of Celtic origins is not easy to prove, for there is no known word which may be offered as the basis for this name. However, there is an earlier language can may provide a clue.

Indo-European is the group of languages from which all the languages of the Indian subcontinent and much of Europe belong. This suggests, but does not prove, that there was a Proto-Indo-European language from which all the rest are derived. In effect this is a purely hypothetical tongue, which shows links to all these tongues and can be related to through the oldest known forms of known languages. All words from this tongue are short and sharp, with the simplest of meanings. It is one of these words which may prove to be the basis for the name of the River Wey.

To define this as coming from the root uegh meaning 'move' may seem overly simplistic, and yet most names describe the river as being simply 'water, dark, cold, flowing, etc'. While this is by no means certain it is the best explanation we have to date.

WEYHILL

The earliest record comes from 1270 as La Wou, a name of Old English origin from *weg-hoh-hyll* meaning 'the hill-spur climbed by a road'. However, there are also some schools of thought which translate the first element as Old English *weoh* or 'heathen temple'.

WHEREWELL

An Old English name from *hewr-wella* and recorded as Hweryl in 955, this is 'the spring provided with a kettle or cauldron'. Obviously this is not a natural feature and yet must have been a permanent one in order for the name to stick. Hence there was some reason for there being a way of heating water here for some time, although what that reason may have been is a mystery.

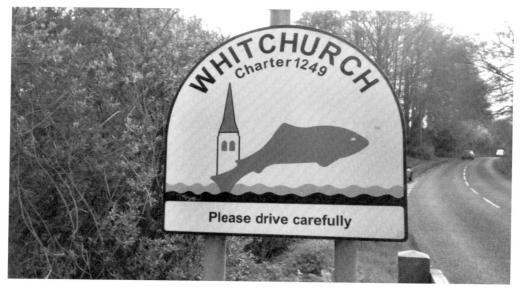

Welcome to Whitchurch.

WHITCHURCH

A common enough place name which comes from Old English *hwit-cirice* and meaning 'the white church'. Listed as Hwitecanryice in 909 the white colouring would point to this being a stone-built church, when most were wooden.

Locally we find Charlcot Farm, a name which is derived from the Old English for 'the cottages of the partly free villeins'. This speaks of the villeins having their freedom part of the time. Twinley Manor is not found before 1615 as Twynlie, however it certainly hails from a much earlier time and the Old English tongue, speaking of 'the double or twin woodland clearing'.

Pubs in Whitchurch include the rural scene depicted on the Harvest Home and the implied offer of refreshment for the thirsty workers, and the Prince Regent, a royal name referring to the man who eventually became George IV.

WHITBURY

The earliest record comes from 1130 as Wiccheberia, a name from Old English *wice-burh* and referring to 'the fortified place where wych elms grow'.

WHITEWATER

A tributary which merges with the Blackwater at the boundary with neighbouring Berkshire. There is no etymological background to this name, indeed it appears to have been named comparatively recently to distinguish it from Blackwater.

Chesapeake Mill, Wickham.

WHITSBURY

A name recorded in 1132 as Wiccheberia and in 1168 as Wicheberia point to this being Old English *wice-burh* or 'stronghold of or by the wych elm'. The stronghold in question is Whitsbury Camp otherwise known as Castle Ditches.

WHITWAY

Recorded as Wytewey in 1245 and Whyteweye in 1280, this name is derived from the Old English for 'the white way'. This is clearly from the old track leading across the Downs, although today the modern A34 has obliterated the age-old trackway.

WICKHAM

Listed as Wicham in 925 and Wicheham in 1086 this comes from *wic-ham*, Old English which means this was 'the homestead associated with a vicus'. The vicus refers to this previously being an earlier Romano-British settlement.

One minor name of interest here is Coldharbour, a name which appears at least 200 times in England though seldom before the sixteenth century. This indicates that something must have started this trend and, for once, we can trace it back to its origin.

The Mill Stream at Wickham.

In London there was a splendid house belonging to the Earl of Shrewsbury which, for unknown reasons, within a few years became little more than a slum. Clearly the many other Coldharbours, including this one in Wickham, have also seen decent living accomodation fall into disrepair within living memory. No record exists of which property is being referred to in Wickham, and it is safe to assume the place was almost certainly demolished.

WIDLEY

With records of this name as Wydelig in 1242 and Wydelegh in 1256, it is thought that this points to the Old English origin of *widan-leah* the '(place at) the broad or wide clearing in the wood'.

WIELD

An unusual modern form which is derived from Old English *weald* and recorded as Walde in 1086 and Welde in 1256. This tells of the '(place at) the woodland or forest'.

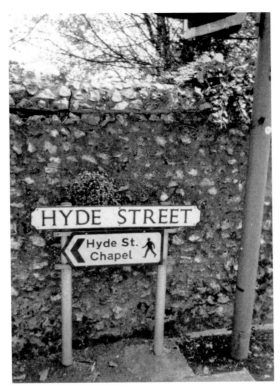

One of Winchester's oldest streets.

WINCHESTER

Records of this place name go back as far as Ouenta in 150, as Uintancaestir in 730 and as Wincestre in 1086. This name means 'the Roman town called Venta', itself a pre-Celtic name meaning 'the favoured or chief place'. As with many Roman towns the suffix here comes from Old English *ceaster*.

To the north of the city centre is the district of Abbott's Barton, a name referring to 'the barley farm' which was owned by Hyde Abbey. At Fulflood we learn of a place which was once a much less desirable place to live as it is defined as 'the foul or muddy ditch'. Bar End is a region outside the former East Gate of the city, denoting where a barrier was erected to control access into the city and most likely a tollgate or similar.

Harestock has a long history, found in 854 as Heaford Stoccan, in 909 as Heafod Stoccum, and in 961 as Heafod Stoccam. However, these three records are from the three neighbouring parishes and point to a rather gruesome sight at the place described by the Saxons as *Heafodstoccas* or 'the posts on which the heads of criminals were displayed'. To show the heads of those executed for their crimes was a chilling and effective reminder of the ultimate consequences of breaking the law.

Hyde Abbey Road comes from Hyde Abbey, which was formerly called the New Minster. The new name came from its situation outside the city walls where the place

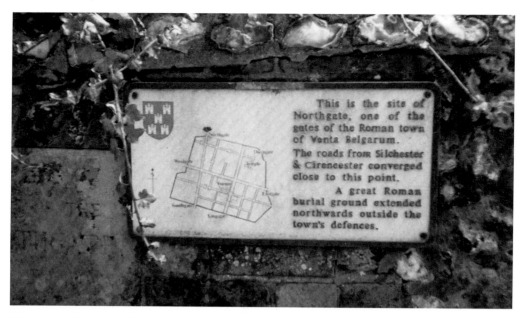

Winchester history at Northgate.

name referred to a land measurement, the hide. Pitt is a region to the south-east of the city which is recorded in the same way as in the modern form as it was in the twelfth century. There is an obvious dip in the landscape here and this is the only logical explanation for this name. Prior's Barton is a former settlement seen as Berton prioris in 1166. Here the 'barley farmstead' was held by the prior of St Swithun's.

Rising 200 feet above the surrounding land is St Catherine's Hill, a hill fort which was the site of a medieval chapel dedicated to St Catherine which was the reason for the place name being listed in 1208 as Monte sancte Katerine. There is also a St Giles Hill which was recorded as Mons sanctii Egidii in 1208, giving the Latin form of the saint's name. However, there was no church here, and this reference is to, of all things, a fair. In the reign of William II (William Rufus) the right to hold a fair here was granted to Winchester. The celebration to be sited on the hill annually and always on the feast day of St Giles.

The hospital known as Holy Cross was recorded as early as 1185 as Domus crucis extra mouros Wintonie, and is a typical example of these early refuges being named from the dedication of whichever church controlled the place for the sick. A district found on the banks of the River Itchen would be quite likely to be called 'the nook of land of the willows' and is the origin of Winnan here.

Streets of such an ancient city as Winchester have seen a number of name changes over the centuries, although High Street has never changed and will always remain historically the most important of them. Westgate and Northgate still exist, yet Southgate had previously been Gold Street and, with Silver Street, was where dealers in precious metals were to be found. Tower Street was formerly Snithelinge Street, thought to be where beggars were a particular problem.

Scowertenstreat is now Jewry Street and was the heart of the city's Jewish community. What is now St Peter Street was formerly in-part Alware Street with the remainder being Fleshmonger Street, an old term for a butcher. Lower Brook was once Tanner Street, a place where leather was tanned and undoubtedly an olifactory abomination. Upper Brooks also has the former name of a trade, as previously it was Sheildwright Street. What is now Trafalgar Street was formerly Gerestret, St Thomas was Caple Street, and Middle Brook Street once basked in the name of Wengenestret. The origins of the so-called Brook Streets date back to Saxon Winchester, when Ethelwold decreed there should be a 'making of the conduits' and thus rid Winchester of pools of rainwater and other less desirable liquids lying in the street.

Minster Street, Great Minster Lane, and Little Minster Lane all take their name from Winchester Cathedral, while Abbey House and Abbey Passage are further religious references. Oram's Arbour recalls former inhabitants stocking-maker Alexander Oram and his son William who, in the late seventeenth and early eighteenth centuries, donated land to the people of Winchester for the purposes of recreation. Furley Close is named after the family who lived at Chernocke House, had a hand in the education of the boys of Winchester, and saw John Furley serve as mayor from 1910-11. Godwin Close recalls John Godwin, mayor in 1725; Devenish Road is named after the family who produced three mayors, including John Devenish in 1317; and Wavell Way remembers the family from whom came Thomas Wavell, who served as mayor in 1671. No less than eleven other terms of office were filled by various members of this family.

In 1958 plans were laid out for the Teg Down Estate and the tithe map was examined for names of roads. From this old map came the names of Goring Field, Down Hill, Coppice Close, Teg Down Meads, Bradley Peak, Croches Croft, and Sarum Close.

Local pubs tell us of Winchester's history in names such as the Old Gaol House, which was previously located here. The pub named the First In Last Out would have been the first or last pub encountered when travelling to or from Winchester. The Eclipse Inn makes for a simple sign, and may refer to a famous stagecoach or the racehorse of the eighteenth century. The latter was born during an eclipse of 1763, won many races, and sired a line which won countless others. The King Alfred reminds us that this was the capital city of first Wessex and then England under the rule of its most famous king, and the Albion Inn is a patriotic name, this is the poetic name for Britain.

The Black Boy is often shown as being the young chimney sweep's assistant of Dickensian literature. Yet the more likely basis for this name is the young personal servants of the rich of that time, who were dressed in brightly coloured and often striped attire which earned the nickname 'tigers'. The Percy Hobbs was known as the New Inn until as recently as 1982, when the gentleman depicted on the sign wearing his trademark cap gave his name to the place, honouring the figure who had been a regular at this establishment for no less than sixty-two years.

WINCHFIELD

From Old English *wincel-feld* this is 'the open land by a nook or corner' and is recorded as Winchelfeld in 1229.

The local here is the Barley Mow, a common name referring to a mow or stack of barley which has been used as a reference to the local brew since the earliest days of pub

signs. In days when travellers would seek out places where refreshment was available, it paid to advertise that they brewed their own. Hence a tree alongside the lane or track would be stripped of at least its lower branches and a sheaf of barley tied to what became known as an ale stake which was effectively the forerunner of the pub sign.

WINSLADE

First recorded in Domesday as Winesflot, this refers to 'the spring or stream of a man called Wine', with the Saxon personal name preceding Old English *flode*.

WINSOR

A name found as Windesore in 1167, as Windlesore in 1222 and Windlesovere in 1272, and is a name which is seen in several places across England. Most of these names are said to refer to the Old English 'windlass bank', which was where goods were raised from a river. There are also examples of the same winding gear being used to raise goods up a steep incline, particularly one seeing a great deal of use and thus likely to become muddy quite easily – there is an excellent example in the centre of Shrewsbury.

The problem here is two-fold, as firstly there is no river which would have provided a transport route and, secondly, while we cannot be certain it was not used to float goods along in the distant past, is difficult to see it as ever having held much water. Furthermore the local population has never been large, thus a major winding gear construction would have hardly been used. Thus perhaps we are looking at a slightly different origin 'windy flat-topped ridge'.

WOLVERTON

Listed in Domesday as Olvretune and as Wuldertona in 1167, this name comes from a Saxon personal name and Old English *tun* and speaks of 'Wulfhere's farmstead'.

WOODMANCOTE

A name meaning 'the cottages of the woodmen or foresters' which is from Old English *wudu-mann-cot*. It is found in Domesday as Udemanecote.

WOOLMER FOREST

A region west of Liphook which derives its name from a place name. This was originally applied to the 'pool of the wolves', which is even further west towards Longmoor Camp.

There is a local name marked on maps referring to Woolmer Post. This is a New Forest boundary marker although how ancient the marker and the name may be is uncertain.

WOOLSTON

Domesday's record of Olvestune is a somewhat corrupted representation of 'Wulf's tun or farmstead'.

Streets of Woolston recalling the history of the place include: Cooper's Lane (Philip Cooper, grocer (1895-1935)) and Cox's Lane (butcher John Bennett Cox who was working here in the late nineteenth century).

It is clear that this is close to the sea as the local pubs are known as the Yacht Tavern and the Seaweed.

WOOLTON HILL

This name was recorded as Woulthorne in 1604, meaning 'the spring of the hawthorn' which has since become somewhat corrupted, possibly through the influence of another similar, and unknown, place name.

WOOTTON ST LAWRENCE

A common place name like Wootton is often found with a second element, here it refers to the dedication of the Church to St Lawrence. The basic name comes from Old English *wudu-tun* and refers to 'the farmstead in or near a wood' and is recorded as Wudatune in 990 and Odetone in 1086.

Woodgarston is a place name recorded as early as 945 when it appeared as Wealagaerstun. This comes from the Old English 'the paddock of the serfs'. Today the name applies only to a farm and the lane that serves it.

WORLDHAM (EAST and WEST)

Domesday's Werildeham is thought to come from 'the homestead of a woman called Waerhild', with the personal name followed by Old English *ham*. The addition of East and West is self-explanatory and shows that both places were originally one.

WORTHY (ABBOTS, KINGS, MARTYR, and HEADBOURNE)

Here is a name with four different additions, all of which are found within a two miles of each other along a single road. The basic name comes from Old English *worthig* or 'enclosure', not a defensive structure but one which provided overnight housing for livestock.

Abbot's Worthy comes from the farmland granted to Bishop Lufinc of Winchester by King Canute in 1026. The royal holding is predictably now referred to as King's Worthy; Martyr Worthy would naturally make us think of some religious victim, yet the real origin is quite innocent, deriving from the Lord of the Manor Henry la Martre in 1201, a man whose family name means 'the marten'. Headbourne Worthy takes its other name from Anglo Saxon for 'the stream of the hides'.

The church dedicated to St Thomas at Worting.

WORTING

Listed as Wyrtingas in 960 and Wortinges in 1086, this comes from Old English *wytring* and means 'the herb garden'.

WYMERING

Domesday's record of Wimeringes in 1086 is derived from 'the settlement of the family or followers of a man called Wigmaer'. Here the Saxon personal name is followed by the Old English element *ingas*.

CHAPTER 23

Y

YATELEY

Records of this name include Yatele in 1248, from Old English *geat-leah* and meaning 'the woodland clearing near a gate or gap'. To the south-west is Blackbushe Airport. The region was recorded as Blakebushe in the fourteenth century meaning 'the dark thicket'. Another 'dark' name is shared by the Blackwater River, which also gave its name to a nearby field.

To the south-east is the region known as Darby Green, named for its association with William de Derby and his descendants who are recorded as being here since the latter half of the thirteenth century. Minley is not a recent development, and is recorded in Domesday as Mindeslei. It is derived from 'Mynda's woodland clearing'.

Pubs in Yateley include the idyllic summer scene portrayed by the Cricketers and the country sports of the Dog & Partridge. The Tything on the Green may not refer to the tax but is more likely to refer to the parish officer who maintained the peace, the seventeenth-century version of the village policeman.

COMMON
PLACE NAME ELEMENTS

Element	Origin	Meaning
ac	Old English	oak tree
banke	Old Scandinavian	bank, hill slope
bearu	Old English	grove, wood
bekkr	Old Scandinavian	stream
berg	Old Scandinavian	hill
birce	Old English	birch tree
brad	Old English	broad
broc	Old English	brook, stream
brycg	Old English	bridge
burh	Old English	fortified place
burna	Old English	stream
by	Old Scandinavian	farmstead
ceap	Old English	market
ceaster	Old English	Roman stronghold
cirice	Old English	church
clif	Old English	cliff, slope
cocc	Old English	woodcock
cot	Old English	cottage
cumb	Old English	valley
cweorn	Old English	queorn
cyning	Old English	king
dael	Old English	valley
dalr	Old Scandinavian	valley
denu	Old English	valley
draeg	Old English	portage
dun	Old English	hill
ea	Old English	river
east	Old English	east
ecg	Old English	edge
eg	Old English	island
eorl	Old English	nobleman
eowestre	Old English	fold for sheep
fald	Old English	animal enclosure

feld	Old English	open land
ford	Old English	river crossing
ful	Old English	foul, dirty
geard	Old English	yard
geat	Old English	gap, pass
haeg	Old English	enclosure
haeth	Old English	heath
haga	Old English	hedged enclosure
halh	Old English	nook of land
ham	Old English	homestead
hamm	Old English	river meadow
heah	Old English	high, chief
hlaw	Old English	tumulus, mound
hoh	Old English	hill spur
hop	Old English	enclosed valley
hrycg	Old English	ridge
hwaete	Old English	wheat
hwit	Old English	white
hyll	Old English	hill
lacu	Old English	stream, watercourse
lang	Old English	long
langr	Old Scandinavian	long
leah	Old English	woodland clearing
lytel	Old English	little
meos	Old English	moss
mere	Old English	lake
middel	Old English	middle
mor	Old English	moorland
myln	Old English	mill
niwe	Old English	new
north	Old English	north
ofer	Old English	bank, ridge
pol	Old English	pool, pond
preost	Old English	priest
ruh	Old English	rough
salh	Old English	willow
sceaga	Old English	small wood, copse
sceap	Old English	sheep
stan	Old English	stone, boundary stone
steinn	Old Scandinavian	stone, boundary stone
stapol	Old English	post, pillar
stoc	Old English	secondary or special settlement
stocc	Old English	stump, log
stow	Old English	assembly or holy place
straet	Old English	Roman road
suth	Old English	south
thorp	Old Scandinavian	outlying farmstead
treow	Old English	tree, post
tun	Old English	farmstead
wald	Old English	woodland, forest
wella	Old English	spring, stream
west	Old English	west
wic	Old English	specialised, usually dairy, farm
withig	Old English	willow tree
worth	Old English	an enclosure
wudu	Old English	wood

BIBLIOGRAPHY

Petersfield Place Names – Petersfield Area Historical Society
Messuages and Mansions Around Lymington and the New Forest – Robert Coles
Fordingbridge News
Men of the Streets – A.G.K. Leonard
Fareham Past and Present – Fareham Local History Group
Oxford Dictionary of English Place Names – A.D. Mills
Hampshire Place Names – Richard Coates